ALFRED CURRIER

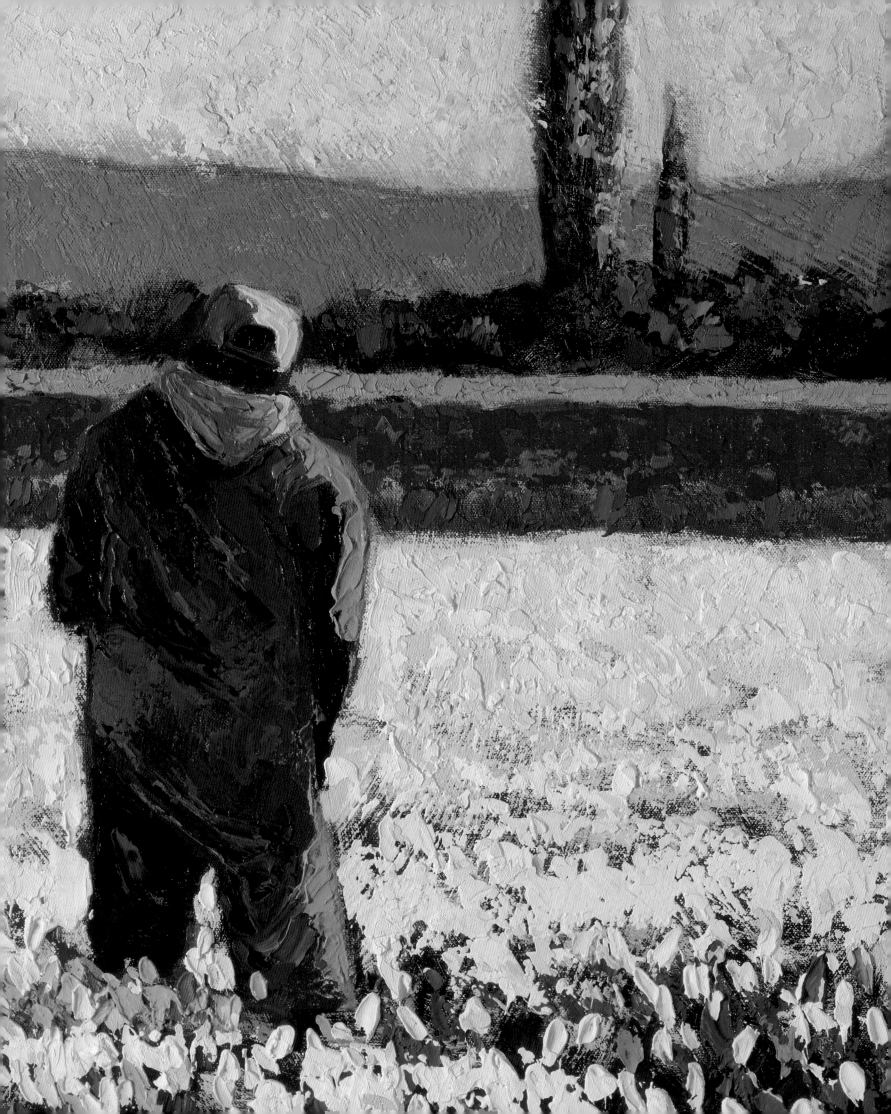

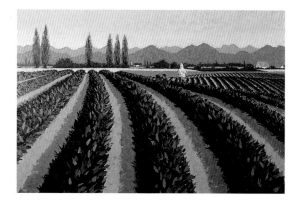

ALFRED CURRIER

Impasto

Ted Lindberg

MARQUAND BOOKS, INC.
Seattle

in association with
UNIVERSITY OF WASHINGTON PRESS
Seattle and London

This book would not have been possible without the generous support of the following:

Doug and Nanci Allen

Mitch and Linda Everton

Insights Gallery

Lawrence Gallery

Don and Molly Mowat

David and Laura Neri

Beth Ashley and Mike Moe

Rich and Gail Ballow

Marge and Hank Bickel

David and Juliette Delfs

Don and Minnie Erickson

Virginia Foley and Sarah Yeo

Lin Folsom

Nancy M. Fulton

Jan Gray and Kerri Fowler

Crete B. Harvey and Thomas C. Bason

Gene Kahn

Ann and Harry Knight

Carla and R. W. Chug Leede

Ken and Allison Masson

David and Pat Mowat

Steve Mowat

Don Olson and Sharon Andal

Lynn Page and Chris Pinda-Allen

Sandy and Elizabeth Payson

John and Sharron Prosser

Gloria Runnings and Howard Kinney

D. Schreivogl

Mrs. Marion F. Slater

Small Planet Foods

Jim and Cindy Straatman

Annette Williams

Carla Zimmerman

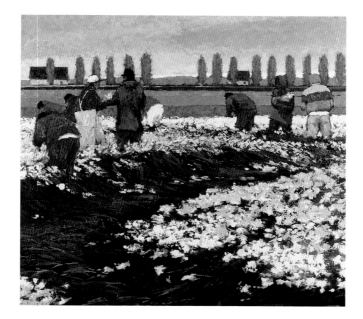

I dedicate this book to the Hispanic migrant worker.

A portion of the proceeds of this book will go to Tierra Nueva, whose Family Support Center outreach program helps migrant workers and their families. Tierra Nueva supplies emergency clothing and blankets, assists people with legal problems, and helps with job and housing applications. Their counselors and volunteers also accompany people to court, visit in detention facilities, and mediate conflicts with employers, landlords, and insurance companies.

Primarily of Hispanic heritage, the migrant workers of Washington's Skagit Valley come from as far away as Central America, Mexico, Texas, and California. Most are a proletariat group of workers who are trying to survive in this fast-paced and competitive agricultural industry.

We appreciate the migrant workers not only for the role they serve in agribusiness but also for the warmth and cultural insights they share with our communities.

— Alfred Currier

Author's Postscripted Dedication and Lament

To Norah Elizabeth Kembar (1934–2002)

My wife, lover, comrade, personal editor, and fellow traveler for the last twenty-eight years;
and who, although out-voted, wanted to title this book "Tulips, Etc."
Here it is in print, Babe.

—Ted Lindberg

Library of Congress Control Number: 2002116473

ISBN: 0-9706394-3-0

The paper used in this publication is acid-free and meets the minimum requirements of American National Standard for Information Sciences—Permanence of Paper for Printed Library Materials, ANSI Z39.48-1984.

Alfred Currier
P.O. Box 1374
Anacortes, WA 98221
www.alfredcurrier.com

Distributed by
University of Washington Press
P.O. Box 50096
Seattle, WA 98145

Frontispiece: *Last Frost,* 2001 (detail; see p. 31)
Page 3: *Skagit Flats,* 2001, oil on canvas, 60 × 84 in.
Collection of Mitch and Linda Everton
Page 5: *First Pick,* 1995, oil on canvas, 40 × 44 in.
Collection of Mr. and Mrs. Richard Snyder
Page 8: *La Conner Slough,* 1995, oil on canvas,
30 × 36 in. Collection of David and Laura Neri
Page 9: *High Ground,* 2002, oil on canvas, 48 × 60 in.
Collection of Ken and Allison Masson

Photography by Matt Brown and Dick Garvey,
except page 107 by Anne Schreivogl

Edited by Michael Falter
Designed by Jeff Wincapaw
Color separations by iocolor, Seattle
Produced by Marquand Books, Inc., Seattle
 www.marquand.com
Printed and bound by CS Graphics Pte., Ltd., Singapore

CONTENTS

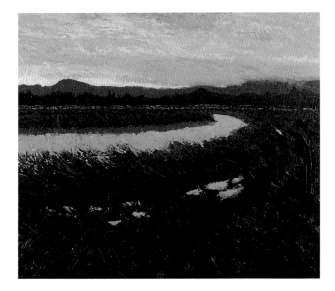

Toward the Sound end of the valley, the fields are rich with river silt, the soil ranging from black velvet to a blond sandy loam. Although the area receives little unfiltered sunlight, peas and strawberries grow lustily in Skagit fields, and more than half the world's supply of beet seed and cabbage seed is harvested here. Like Holland, which it in some ways resembles, it supports a thriving bulb industry: in spring its lowland acres vibrate with tulip, iris and daffodils; no bashful hues. At any season, it is a dry duck's dream, bedded with ancient mud and lined with cattail, tules, eelgrass and sedge. The fields, though diked, are often flooded; there are puddles by the hundreds and the roadside ditches could be successfully navigated by midget submarines.

—Tom Robbins, *Another Roadside Attraction* (Garden City, N.Y.:
Doubleday & Company, 1971, pp. 79–80)

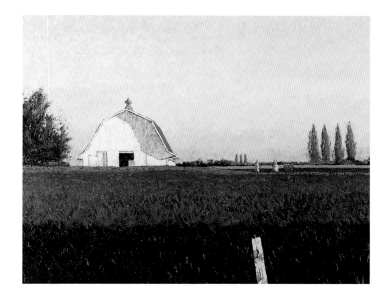

PREFACE

I once wrote a short, albeit celebratory and positive, piece on the work of painter Alfred Currier (see Appendix) based on relatively scant information and the slightest personal contact. It is easy, in a quick take, to barge ahead on what one surmises about an artist's accomplishments without getting seriously into the matter. Since on one hand the paintings seemed exclusively landscape-generated, one could simply inject one's own knowledge of the same locale and not be far off. I talked about the nature of Skagit County, Washington's physicality, particularly the flat Skagit River delta region with its weather and moods, the changes wrought by the first settlers to this place, and, above all, the psychic energy once derived by the Northwest school painters. I avoided altogether what has come to be Currier's signature style: the recurrent rendering of the Skagit Delta, particularly the blossoming of its famous tulip fields (more extensive even than those of Holland), and the people that work in them.

I was unaware that Currier had been living and working in this county for only ten years (he was born in New Jersey in 1943, grew up in Ohio, and has traveled and studied widely in the United States and abroad); I was likewise unaware that he considers this decade as his professional coming of age—the crystallization of a personal style and technique. Most importantly, I was oblivious of his theoretical approach to making a painting—the difference between what he calls the commercial aspect of a painting and its aspect as fine art. It turns out that the subject or content of a painting has little to do with what interests him most, which is the process of painting. It is in the application of paint by brush or paint knife—stroke by stroke—that he has found to be the actual artistic experience, and it is his hope that the viewer will respond to the singularity of his art and craft. This recent unifying decade in the career of Alfred Currier is the focus of this book.

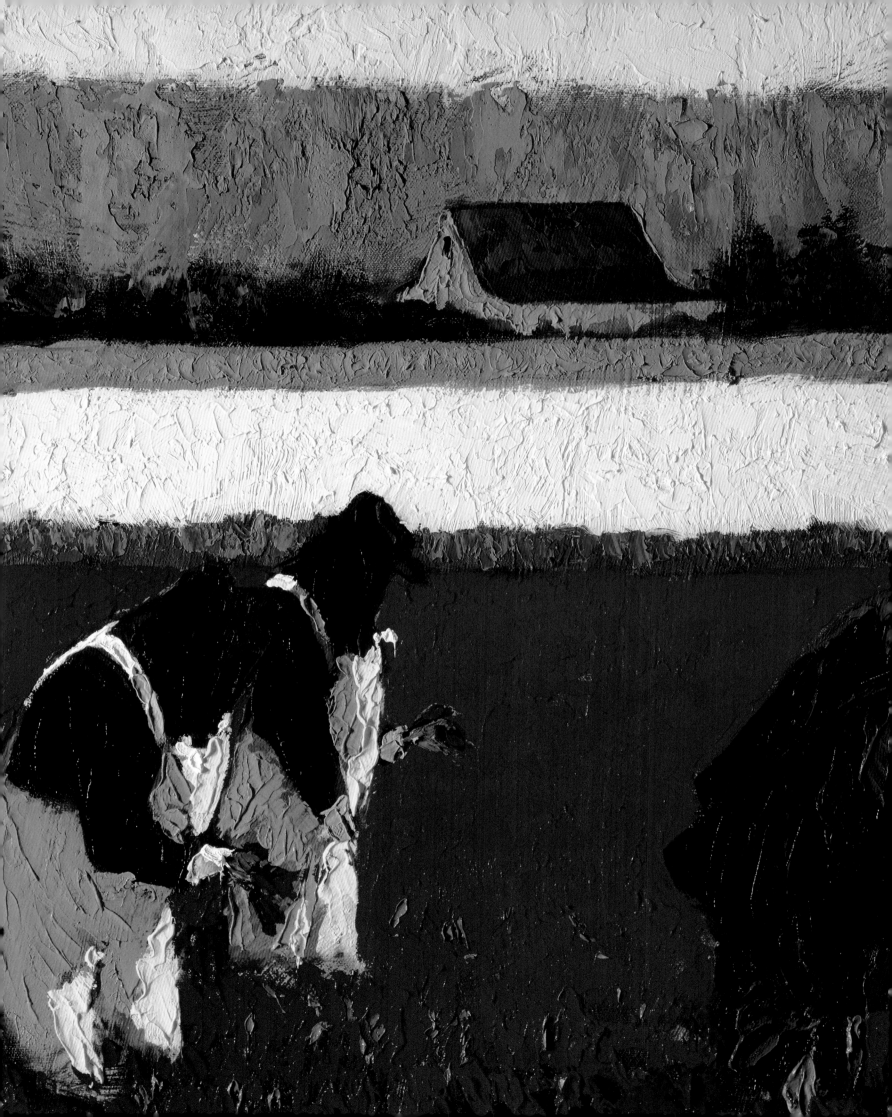

THE TECHNIQUE THAT TURNED THE TIDE

To appreciate Alfred Currier's work we must first frame it within the long shadow of art history and critical interpretation. Without pitting Currier against the vastness and diversity of art history, we can find organic connections. Why, with today's instant communication and imaging, would anyone choose an antiquated method of making pictures by spreading a medium the consistency of margarine with a brush hardly more tractable than a toothbrush or a knife shaped like a miniature mason's trowel? Art history and criticism do not entirely explain the enduring mystique of paint and painting. The explanation lies more in the realm of romance and provocation, and for Alfred Currier it probably started innocently, more tied to the engrossment of childhood doodling and drawing.

Like many artists, Currier was a compulsive draftsman from an early age. He was noticed and appreciated and rewarded; he was talented. Upon entering art school at the Columbus College of Art and Design, talent was still all he had. He thought of becoming a cartoonist or an illustrator or working in an advertising agency. He had to make a living and these were professions with respectable salaries. "Somewhere along the line I took a painting class. It was a beginning class, and the instructor introduced me to the world of 'fine art,' you might say. It seemed to me that there was a philosophy behind it that would ruin for me the commercial aspect, or the illustration part. Being from a fairly conservative community, I didn't know how to make a living as basically a painter." But Currier was kissed by the painting bug.

"What I did was get married and become like everybody else," he says, "with two-and-a-half kids, a dog, a cat, a boat, and a house with a white picket fence." Like many art academy–trained painters, he took "job-jobs" to support his family, but soon decided to pursue painting. On the advice of a friend, the Canadian-born artist Alan

Side by Side, 2001
(detail; see p. 23)

Gough, who had been a student there in the early forties, he entered the American Academy of Art in Chicago.

Artists from the "Chicago School" favored straightforward, traditional landscape and figurative work, despite the shift to surrealism and abstract expressionism in New York and other major cities in the East. Elsewhere in North America, too, there was continued respect for devoted regionalist, expressionist-impressionist-style painting such as evinced by the Canadian Group of Seven, the Hudson River school, and the so-called Ashcan School (a.k.a. "The Eight"). The latter was the first formally constituted group of American artists (notably Maurice Prendergast and John Sloan) to make their shared purpose the creation of a native style that reflected the American experience by painting images of gritty urban street-scenes and working-class haunts.

During Currier's training, like-minded groups were still coming out of schools such as the Art Students League in New York and commercial academies around North America. Currier wanted this kind of solid academic training because, if nothing else, he was a draftsman with representational leanings. Opting for the "fine art" of painting, he quickly learned that drawing is not painting; that drawing might be making thick and thin lines, cross-hatching, and so on, but painting is an approach to form opposite of the linear. It must be form seen as areas of mass, color, light, and shade.

Currier and the artists he began to respect were not interested in current "art fashions." They thought of themselves as a separate era, even if it represented "a kind of time-warp that I was already caught in." Art vogues came and went: pop art, minimalism, color-field painting, conceptual and performance art—and even the ultimate denial of painting's primacy in the visual arts. In the seventeen years between Ohio and Skagit County, Currier honed his technical skills and continued supporting his family with non-art-related jobs, though he eventually began teaching art.

Currier made the decision to pursue art full-time in 1978, but it was not until 1992 that he earned a minimal living wage from his art. This period includes forays to other cities and jobs. He came to Skagit County from Kansas City with his second wife. He was forty-eight.

It probably wasn't till I moved to Washington State and saw people really exploring, in a little different direction, that I realized I really had to get art back to where I was as a kid [in relation to] the process of *doing*—which was [how] to remain an artist once you become an adult. I was kind of looking for that "child" again. I love fooling with different mediums: sculpture, oil painting, watercolor, drawing with charcoal. I've got my painting reduced down to [one derived from] a simple pencil sketch. And sometimes not even that. Sometimes I get right into the painting, drawing on the canvas with a brush and some alizarin crimson—a transparent color—and I'll just draw on the canvas, and sometimes my painting will emerge from that . . . generally, the faster the painting, the better.

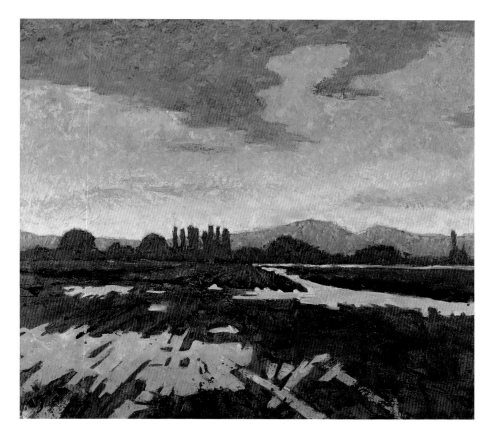

If Currier became a "neo-regionalist" after arriving in Skagit County, the transformation did not happen overnight. Like anyone, his senses had to become attuned to the region. He became acutely aware of its light, color, and primary forms. He was already prepared to record his impressions with a highly practicable approach to oil painting, as set down by his guru, Ted Smuskiewicz, who teaches at the American Academy of Art—a generalist, manipulative approach to "setting and furnishing a scene." This technique can be bent toward fine art or illustration of the type used in tonier magazines, but it is firmly based in the major tenets of modern painting, from the time of the impressionists and then the fauves ("wild beasts"—the term used by French critics who deplored the brilliant, luminous color and gestural brushwork adopted by painters such as Matisse and Derain) to the wide current of "realist" American painting that has remained more or less stabilized for a hundred years.

Currier explored: from the shores of Puget Sound to the west and the saw-tooth ridges of the Cascade Mountains to the east. He did and does plein-air (outdoor) paintings and drawings, always traveling with a compact kit and folding easel. He also created a comfortable studio and a daily routine. Images and compositions gleaned from his travels were increasingly transformed from plein-air oil impressions into fully developed studio paintings. As a rationalist, he had no compunction about changing things around: cropping, reversing, reorienting, moving from naturalistic tone and color to those that were invented. He soon realized that the Skagit Delta lends itself to abstracting or "shorthand" strategies.

Looking at his plein-air paintings, he can recall the exact conditions, smell, temperature, and "feel" of the site. He is also conditioned in his studio time, where he works to music: rhythm and blues, symphonies, operas—anything, he says, except

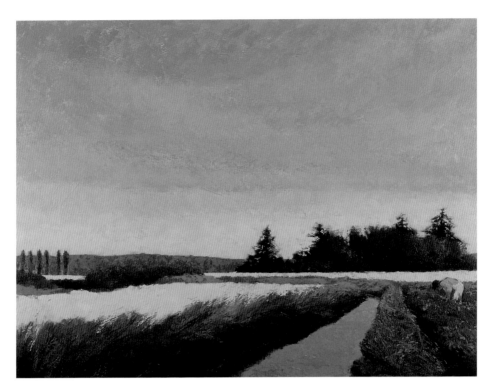

country-and-western. Listening to music while working puts him into a "zone." His work is propelled by mood, tempo, cadence, and musical "color." He doesn't worry about intrusion, weather, time constraints, or the shifting or waning of light. He drinks coffee. He talks to his dog, Boo.

In Currier's view of this recent decade of development and stabilized resolution in his work, it is the mastery of a strong impasto technique in paintings evolved from simple, preliminary drawings, and his experimental discovery of proven mediums and permanent colors that have turned the tide. Currier's paintings, like those of the impressionists and fauves, are not magic windows into another world (the historical objective of photo-realist academic painters prior to the rise of modernism). He wants the viewer to know he is not looking through a window but at a painting with all its unique physicality and complexity—daubs and gestures that are actually abstract shapes rendered by brushes and paint knives, having nothing to do with a photo-graphic vision of the world.

Currier's repeated employment of tulip fields and migrant workers leads to the question: Is he a serial painter? These scenes compose a large portion of his 1990s output, worked over and over with variations and reorientations and with subtle alter-ations of color, mood, and light. Yet they are not serial because they are not exactly the same concerted analysis of the landscape, as in Paul Cézanne's renditions of Mont Sainte-Victoire, or Claude Monet's poplars and haystacks. As far as the figures are concerned, "I've basically used three figures. I use the same people over and over again—as metaphors, you might say. It's more a celebration of them, [the *braceros,* or field hands,] who actually work the land."

All told, Currier's 1990s production is "ten or fifteen percent plein air—the rest of it would be the impasto paintings. If you break it down in time, about one percent is plein air, because the impasto paintings take so long."

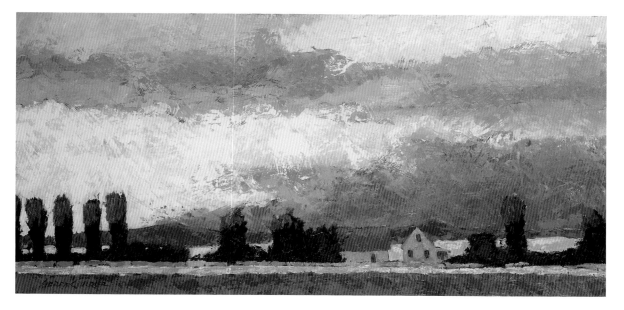

Fields of Gold, 1996, oil on canvas, 18 × 36 in. Collection of Dick and Candy Garvey

"Plein air," he says, "is more instant gratification. If I need to use a slide or a photograph [for reference] in studio work, I always put it away before painting . . . if anything, I use a drawing. You're putting borders around yourself if you work directly from a photo. I feel that the drawing and compositional part, selecting what to paint—that would probably be the commercial aspect. I have confidence in my competence, that I can do that. Once it's laid out on the canvas, from that point on, I think, that's where the 'creative' takes over: that's the most important in my mind."

Process, for Currier, is the intuitive part of the painting, starting with the automatic drawing he makes with gesso on the primed canvas. It becomes his psychic fingerprint for that work, a seismic reading of his mood or disposition. The texturing gel is left to harden, then inundated by a conscious manipulation of space over it—the horizontal and plumb lines of rectitude, the ought-to-be of a structured, reasonable world. It is reasonable because it can be charted out, "parsed." Practical reasoning insists on covering the automatist "outburst" with structure, and that, to him, is the blocking out of a "story." The process of color mixing and the laying-on of painterly application is the "art part." It is a continuing set of compromises, between the commercial and the artistic requirements of each painting.

In Currier's paintings there is always a balancing act between abstraction and realism, between a kind of social realism and landscape-inspired impressionism. He would never want to be thought of as a mere illustrator, having long since opted for what he understands to be "fine art" and the freedom of invention it provides him. Fine art, for him, cannot be narrative art, subservient to some other cause.

Currier hastens through the beginning, compositional part, of the painting, both in the selection and placement of figures and the "executive decisions" about framing, relative space, and perspective. Both figures and landscape are "burned into his consciousness" from long experience in the same locale. Then there are the variables of light, tone, and color and the various ways (virtually the same) that color can be achieved. Even so, the painting is made one stroke at a time.

These strokes are accreted like pearls to cover an irritation of a grain of sand in the creative itch. Currier's joy is in the layering of transparent and opaque values

into contoured expanses, valleys, and plateaus, made by the broad, final-surface brushstrokes or paint-knife swathes that are intended to represent several square feet, yards or acres of a plane suspended in space. These are the master strokes—the illusory tricks that call for suspension of disbelief.

Currier obviously uses these enormous stands of tulips, daffodils, and irises to achieve big stripes and swatches of bright color that otherwise would not exist in Skagit County—not even in the autumn colors of the Cascades, where the soft yellows of aspen and cottonwood only hint at the brilliance of fall further east. Most people's impressions of this region are the restrained color values shared by the Northwest school painters: moody green and gray and dun colors under overcast skies, with sometimes a break-out of late-day sunlight. There is a lot of underlying red in the light, Currier says, brought on by refraction through moist skies: much of his underpainting is in reds and umbers. Auras or penumbras of these colors are seen at the edges of his final shapes—the bands of mountains, trees, buildings, and differentiated fields.

Currently, "proletarian figures" (a term used in at least one newspaper review of his work) are central and primary to his painting, but they serve as focal or spatial devices for locating the angle of perspective (viewer's point of view) rather than as an exploration of the human figure or social status. Never more than blocked-out shapes, they are often in the awkward poses that characterize "stoop-laborers" in the Skagit Delta flatlands. Currier's sketches of rough-hewn figures bring to mind the studio methods of Clayton S. Price, a 1930s modernist pioneer in Portland, Oregon, who worked out his compositions arranging maquettes of buildings and houses and carved wooden figures of people and animals on a table. Currier moves his pieces around with a few drawings and his abundant color sense.

Alfred Currier's paintings of the Skagit tulip fields can be thought of as devices, as emblems, as surely as are Jasper Johns's American flags and numerals or Tom Wesselman's Great American Nudes. In the same way, these paintings are done to bring our attention to the underlying process of art-making. What all these artists are saying, with only variations on theme, is that *painting the painting,* not the subject matter, is what's important.

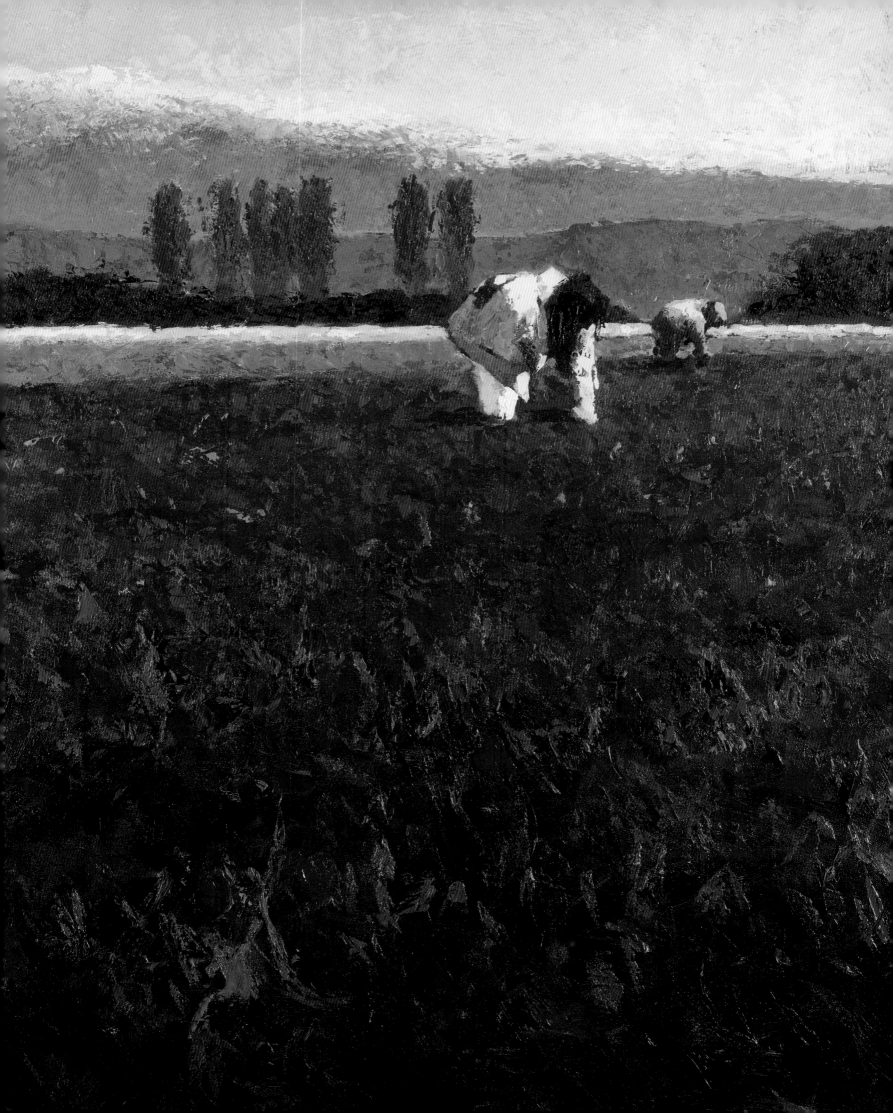

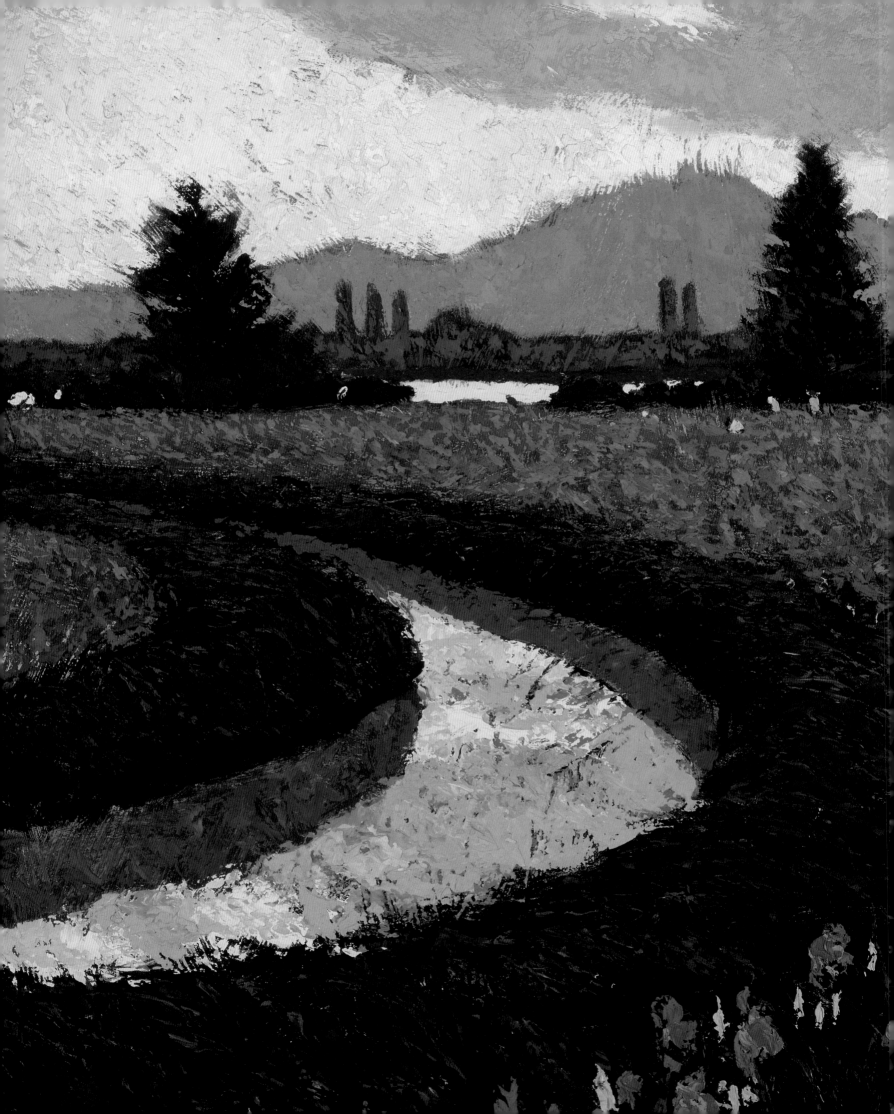

PUTTING ONE TOGETHER

Looking at Alfred Currier's paintings—critiquing, interpreting them—is one thing, but witnessing the creation of a painting is something else again. Currier agrees to let me watch him at work on a canvas, from start to finish. This is a compliment. Although Currier paints before an audience in his workshops, having an observer witness a painting made with serious intent, one that should stand with his official body of work, is precarious. Few serious artists submit to such scrutiny. It is, as it were, performing naked. Most artists are jealous of their privacy and will not even show an unfinished work. This experience represents an intimate disclosure for the artist and a unique opportunity for an observer to critique one of his paintings.

June 13, 2001 The marked difference between Currier's plein-air paintings and his studio paintings is his increasing concentration on impasto—the fact that this has to be applied in several different stages, with waiting periods in between. In plein air, as he says,

> I use no medium—you start and finish in one session—and you can do that without using mineral spirits or turpentine, with the exception of the initial wash to tone the canvas. In studio painting, if you start and stop, you do have to use the "fat-over-lean" principle; that's the beauty of plein air. The problem occurs when you work on a painting over days and weeks. If you don't add oil, then the underlying paint will soak up the oil leaving dry spots.
>
> My feeling is that painting plein air is an acquired technique—it takes a lot of organization, it's more technically based. Painting outdoors is like fly fishing. It's just nice being outside and responding to it, but in my studio, the impasto painting draws from within a little bit more.

Delta Bloom (detail), 1999, oil on canvas, 30 × 40 in. Collection of Ann Blake

Sketch for *Delta Bloom*

Sketch for *Side by Side*

Currier fixes in place a stretched and sized canvas on his impressive cabinet-worked and adjustable easel and sets to work. Beginning a running commentary (punctuated by the silence of concentration, momentarily forgetting he is not alone), he says he buys his canvases from a company in Seattle in various sizes, weights, and weaves. These he resizes. He recoats each canvas with heavily applied gesso to get a textured effect in the underpainting that will "move the eye around." This suggests he is already mentally preplanning a specific picture: a time, a place, and a mood. In this case, he has chosen a 30-by-40-inch, 14-ounce cotton canvas. He doesn't use linen in the Northwest; it's so strong that in a change of environment, such as the dryness of New Mexico, it can warp or pull a stretcher apart. On occasion he does use linen canvas glued to board, especially for the type of plein-air painting favored by the Canadian Group of Seven painters, who used heavily textured canvas to get their gritty, outdoors effects.

He finds two simple line drawings of Skagit field workers, done close-up. The figures establish scale, like a documentary photo of an object with a ruler lying alongside for comparison. He then considers how he might arrange a composite of elements from both drawings.

He washes down the canvas with a pigment-and-mineral-spirit mix.

His palette (used by an old friend, Richard Schmid) is a piece of plate glass with gray matt board underneath so he can comparatively read the colors. It is arranged from the upper right: flake white to Naples yellow, cadmium yellow to cadmium red

light, cadmium red deep to permanent alizarin crimson to transparent earth orange, perylene red to yellow ochre. Then, on the left side, from the top down, the cooler colors: cadmium green to cobalt blue, viridian and ultramarine blue.

As a right-handed painter, I need to have the colors across the top, down the left side, so as I'm reaching for my paint, I always know where every color is automatically; and I never cross my arm over pigment.

My palette changes from time to time, but let's say in warm colors there are certain colors that I would never get rid of: Naples yellow, for instance, just a beautiful color; cadmium yellow medium, cadmium red light, to permanent alizarin crimson, to a transparent earth-red—those would be the basic colors. In the cool colors, I would use cobalt blue, viridian green, and ultramarine blue.

Sketch for *Volunteers*

Every color he uses is exhaustively tested. "Before I add or subtract a color to the palette, I test it by mixing it full-strength on a piece of matt board one inch wide and four inches long. I'll paint ten rectangles (for example, full-strength alizarin crimson, down to the lightest value, by adding white), then I'll cover up one side of the board and put it in a south-facing window, and leave it there for a year. At the end of the year, I'll see if there's been any color change. I do this for every new color I introduce to the palette, to make sure it is archival."

He likes to mix all his colors before he starts: nothing is simply out of the tube in a studio painting. His stocked paint is in a closet, behind his easel. He buys everything in quantity—for instance, thirty tubes of white paint at a time. He orders some paint in quart and gallon cans from Gamblin Artists Colors and sells to other artists so he can maintain wholesale volume.

Before any thought of how he will draw in the figures (a compilation from the two selected drawings), he begins applying areas of transparent washes to what obviously will become a Skagit Delta landscape (see p. 22). He says he will try to paint complements against each other (blue sky will get red underneath—warm under cool; red will get a foundation of cool color). He is also "dirtying up the canvas," establishing an amorphous "presence" in the daunting white void. He says the rust and blue-gray brushstrokes will suggest direction, movement, possible combinations.

The surrealist concept of "pure psychic automatism," or nonobjective gesturing and mark-making, is thought to come directly from "the soul." These ghosts of free-form painting will remain the literal and psychic vertebrae of this work.

He draws in the figures in permanent alizarin crimson, placing them so that an imaginary horizon "goes right through their eyes." The yellow-orange wash has about dried. Currier cleans the center of his palette with a razor knife to avoid any adulteration in the next values he is about to mix. He now establishes a definite horizon about a quarter of the way down from the top of the canvas, and above this, a mountain ridge. A spot of texture will create a "tension link" between mountains, horizon, and figures, he observes.

He moves on to concentrate on the center of the painting and on the composite drawings he has selected. It's a silent decision—it just "happens," he says, in the

blocking out, measuring, of relative scale. Since the eye level and the horizon line
are the same, the heads will be the same height, but lower torsos and foreshorten-
ing will indicate relative distance. He has chosen one figure he likes, and he begins
to develop it a little more and to arrange the other three figures in space.

This is all freehand, of course. Currier, in his trim gray smock, stands squarely
at the canvas and holds his brush at a straight ninety degrees to the picture plane.
There is no copying directly from the sketches. He changes color to adjust the first
figure: "trims down"—does some wiping with a cloth. He adds more purplish lines to
this figure; this takes about fifteen minutes. A second figure is further developed,
also in permanent alizarin, a bit back from the first figure. "Tulips and irises come
a month apart," he says; he gets criticisms from field owners about literalness if he
alters his species of flowers and times of year.

Bobbing, weaving, and talking, he continues to block in the second figure. He
rinses out and wrings his brush (slightly changing the color value) and begins a third
figure: this one is more square than round. He works in simple lights and darks. This
new figure is again chopped at the knees (wading in the flowers). There are now
four values going on in the figure: rose-grays and lavenders as well as purple and
permanent alizarin. The fourth figure, he says, will be "someone breaking his back."
He stops and changes brushes (selected from jars that contain perhaps thirty)
because his initial brush has "given out" (gone soft).

In the stooping figures, relative distance is determined at "knee-line," and the
fourth figure is also cut off at "elbow-line" (arm inserted into a river of blossoms).
He arranges his sentinel poplars—one, two, three—and a line of round hedgerow
trees. He applies a house shape and another poplar behind it. More hedgerow on
the horizon—still in permanent alizarin. This suddenly becomes a busy "horizon band."
In a typical Currier landscape, everything will end up as "bands" or "waves" of mass
or atmosphere.

He cranks up the easel to work on the foreground. There are some wipes with
a paper towel—"softening things a little," he says. The horizon line to the front of and
stage right of the closest figure, Currier says, "feels pretty graphic, right now." He
takes a moment to reflect. The detail, he says, is pretty much about dark and light.
The figure bending over still doesn't "read right" to him.

It's noon. He talks about the amount of time he has spent in the "tulip area"
and how it enhances his ability to make confident decisions in the studio, which
is a completely opposite approach to plein-air or Barbizon-type painting. There are
four poplars so far, and then, left of the house, he places another stylized poplar,
receding further so that there is now a "lateral line." He says he is building a "story"
in his mind. It is a "spatial story" in his serial repertoire of "two-hundred tulip-field
paintings, or whatever."

He studies the two original drawings—still worrying how to integrate them.
This underscores his intense reliance on placing his figures in a credible space.

Beginning stages of an
impasto painting

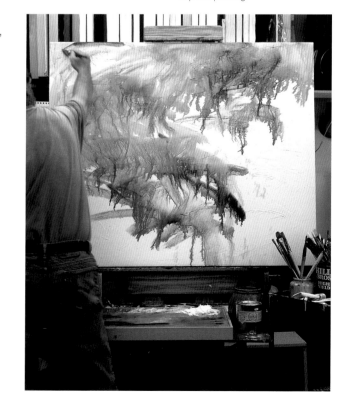

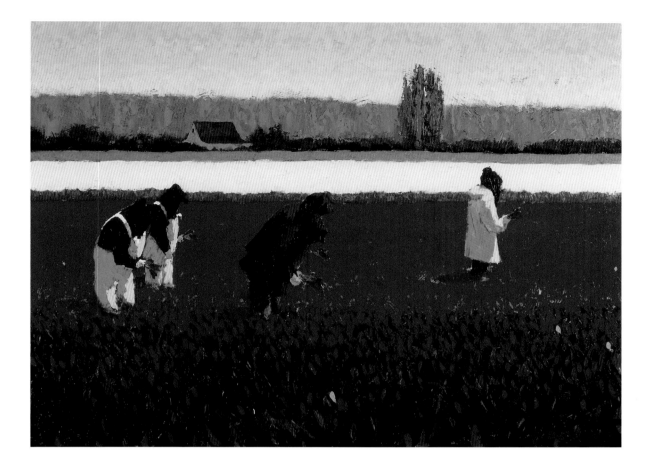

Side by Side, 2001, oil on canvas, 36 × 48 in. Collection of Hank and Marge Bickel

He turns the painting upside down, wipes the edges, and fixes it in place on the easel; regards it. He says he is looking for the *main demand* of the composition, and that, "If you turn a painting upside down, so that it appears the foreground is coming up over you and the sky looks so flat you could walk out on it, it probably 'works' from the perspectival aspect."

He rights the painting and roughs in more areas in the lower right quadrant—wipes a bit of surface moisture off. Will it be standing water with reflections? Shadows on water? He wipes off a large area below the figures. Shadows and areas that look like light blue "sky holes" into some other picture. As the painting dries, the values become stronger. The remaining blue-white wash could almost be a finished surface.

Currier puts some darker shadows on the figures—the shadows read as mini-abstract shapes. Unimaginable patterns: the angle of light and shadow on the inner leg of a figure's overalls. He uses mineral spirits on a brush to erase areas, then wipes with a paper towel. "This is more figure reduction to correct scale and distance," he says. He is still essentially "drawing" at this stage, not "painting." The color blocked in remains underpainting. It is difficult to imagine what the final values might be. Impasto is still several days away.

He says the blocking in, just now in thinned viridian green, is the transparent "approximation" of color. He avoids "deadening" color by making major transitions after this point. The house is the first introduction of white; mixed with more opaque colors, it comes on as a bluish-reddish gray. But he is also letting edges of the original underpainting show through, so that there is a kind of reddish aura around the house shape. As he continues, (he points out) he makes sure that the same brushful

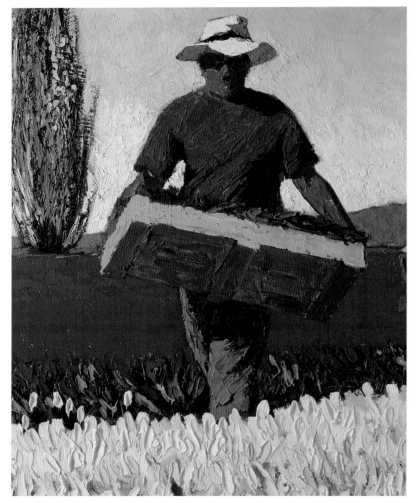
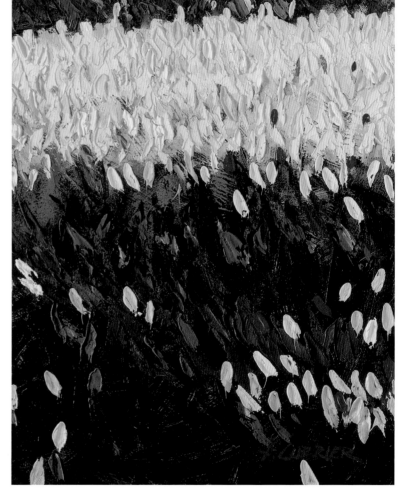

Details of *Volunteers*

of "value" is everywhere in the same horizontal band across the canvas—before the brush runs out. This is the "mountain band."

The "sky band" is next, a peachy white. Everything after this, he says, will have Gamblin's alkyd gel in it to prolong pliancy. The gel allows thick paint to dry in a flexible state, unlike typical oil paint, which will become dry and brittle over time. He says he'll progress from warm on the right to cool on the left. As he paints sky areas between the towering poplars, he again leaves edges of reddish underpainting as "auras." Working from the left edge of the "sky band" he makes a greenish tinge from Naples yellow, cobalt blue, and white. He says, "this is typical of Northwest skies, along with a lot of red from refracting light; air has so much moisture here."

He again blocks in the roof of the house with some of the (mainly) sky color, careful not to build up too much of a hard edge: "It will come, anyway," he says. He will start on the figures now with final color but wants to think about it for a moment—before the landscape gets too developed. He thinks the field behind the figures might be yellow, but (this time) doesn't want a foreground of red. He addresses the dark values that will appear on the figures, but he wants to keep everything transparent. He scrapes the palette again, to avoid contact with any "opaques" and switches to a narrower brush.

All this time he has been drawing in bits and pieces of the landscape without direct reference to previous notes or photos. He says this is not like thirty years ago, when he couldn't have worked like this. On one figure—the most distant—he places a dark green hooded coat. On another, he applies bright yellow—waterproof overalls— it is a sunlit yellow, dense, sculpted. He gives another figure (these are all male, by physical attitude and body shape) blue-gray coveralls and a gray baseball cap. The figure in the center (of three) now wears a sort of navy peacoat jacket. When Currier "cuts in" the surrounding ground, it will be used to determine the final lines of the figures. All this has been executed quickly, even the mixing of the diverse colors. And now he will "tone" the lower left-hand corner, in dark-to-green, ultramarine blue (cold): the result near black. He adds ultramarine blue to the fingers of shadows now extending from lower right. He has significantly darkened the whole lower half of the painting. He has again added a bit of alkyd resin, which he says will "contain a sheen" tomorrow morning. Should he add yellow pants, he wonders? A bluer or more yellow sky? He is deciding still, and says, "there is not as much texture in the gesso stage" as he would have liked to have.

June 14, 2001 By the time I get to his studio, Currier has already formalized the horizontal bottom of the painting—a solid patch of shade—in darker blue, lavender, and green values, some of which creep up and around the three closest figures. He detects an arc at the narrow light-green stripe at the horizon and works to rectify it as he applies impasto.

Some of these paint-loaded knife smears are dragged out so thinly that the "texture ghosts" of the underpainted gesso immediately start to show. They look

Volunteers, 2000, oil on canvas, 40 × 30 in. Collection of Mr. and Mrs. Norman Metcalfe

like combed marks, creating and suggesting their own effects aside from the drawn and painted surface that has come later. It is also apparent that they will be the foundation of the barklike surface that builds up in "plateaus" like a contour map, in unexpected abstract patterns.

He cleans the glass palette and applies piles of color for a different palette. All cadmium yellows will become duller with white, he says, and the hansa range of yellows will intensify with white. He is ensuring he has a full range of prepared color; he doesn't want to stop and remix. Meticulously, he continues to pick up spots and drops of "contaminated color" from the palette. The alkyd resin applied in the under-painting will stay in its tacky form for about a week. He warns me that he "will pace a lot." He starts matching color in the sky (right) with a small paint knife. Yellow and white. It's like miniature plastering—knife held in right hand, which can point from six to twelve o'clock. He's worked an area roughly halfway across (but can go back, as well, integrating). At this point, he has four pools of paint in mid-palette. Now more greenish yellow (at left corner, top). He says the knife is razor sharp from honing across the mineral pigments on canvas (and that he almost cut his finger off once, wiping the blade on a bit of towel). He works back in, repeatedly, and the subtly variegated plateaus of paint pile up.

This work is now grounded entirely in experience and preconception: there are fixed elements in every painting, he reiterates. He can "make the weather change about as fast as the real weather changes," he says. There are about nine distinct "band-scapes" in this painting. New paint is added over most of the canvas, all similar values: red to yellow to blue. Tomorrow, he says, he will be going back in with triads of color: red-yellow, yellow-yellow, and a blue-yellow in the sky. It will have a differ-ent feel—pulling paint across, creating a "fragmented" sky. Spots and patches of new paint will not mix with semidry underpainting, augmenting the "barky" surface. He reddens the warm end of the sky even more—it's now almost salmon colored. He holds up the loaded knife like a swatch and makes comparisons across bands of color before he touches down anywhere. Wary of stray color, he again scrapes the center of his palette clean with the razor scraper. He intensifies each color band. He mixes bluish values for the "mountain band" (blue/gray/violet) and tentatively works it in, this time with downward strokes of the knife. "It's like pulling down a shade," he says. More texture appears through from underpainting as he scrapes new paint thinly over older paint. Watching the painting emerge is hypnotic.

He applies a lighter green in the "tree band" and then reddish highlights on top of the lighter green of the poplars with upward strokes—not the same hot-to-cool grada-tion as in the tree band—and now some olive values. These appear drier and adhere only to the textured ridgetops. The knife strokes are not lavish and wide and thick—they are more tentative, exhaustively worked. He drags the gray of the house roof down a bit into the obscuring tree. He returns to the narrow green band with some new pigment, which seems to be the identical color.

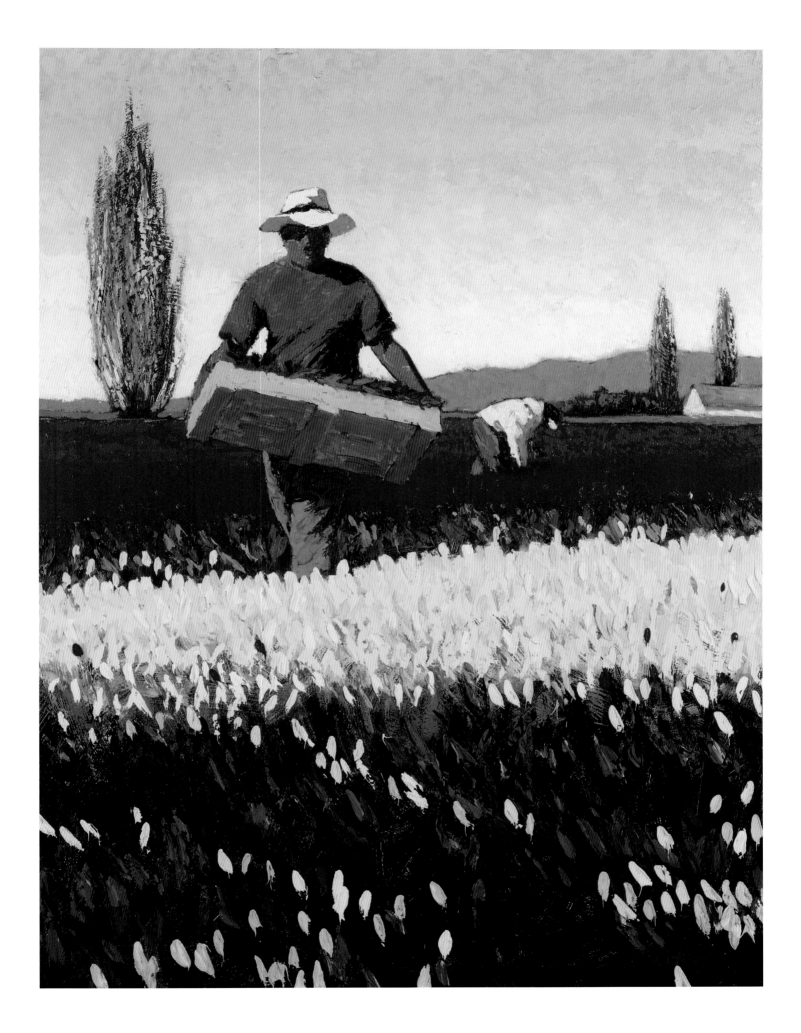

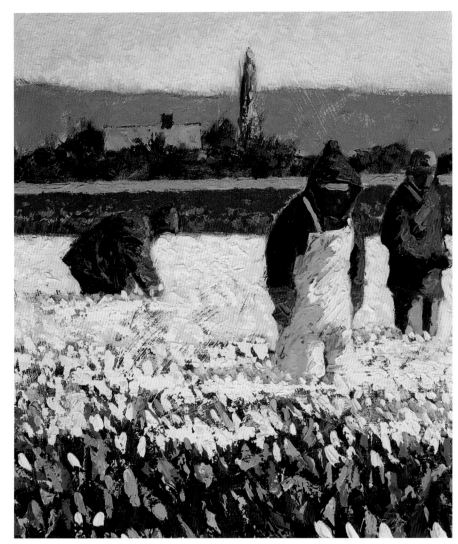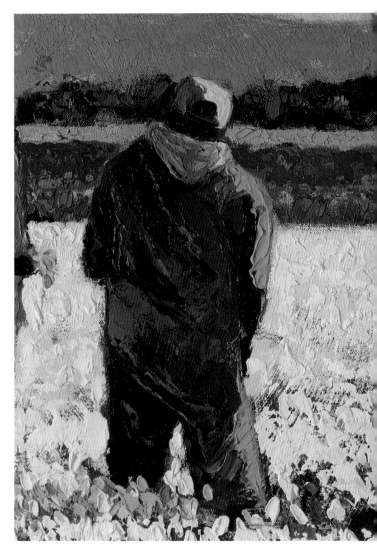

Details of *Last Frost*

Currier, in a critical moment, gauges the final intensity of the red band–tulip field. A similar band appears in another, finished, painting hanging in the studio, which, he points out, is actually darker. His eye for tonality and intensity is hyper-sensitive and it registers immediately. He touches up the second green band that runs through the figures, using the same value, it seems, but of course he also adds texture. This time, it is a spiraling motion with the knife tip. Now into the rose-colored "tulip band": it looks like the same value again, but since it's mixed with alkyd, it's "juicier" and, in fact, could be "worked back into tomorrow," he says, "when I may have another, or better, idea." He mixes up some light pink—this could be for color variations in the blossoms. Even though the tulips don't vary in color within the same species, there is still the matter of shade, translucence, and re-flection. His knife is not only sharp, but pointy. He can use it almost like a straight steel pen nib to render narrow lines, but at no point is he drawing. Rather, he makes abbreviated dabs that approximate effects. The texture creates its own illusions—imaginary beings that the brain insists on reading like tea leaves.

June 15, 2001 Currier now lays in color, works back into the sky, and waits for partial set-up in other areas of the painting. He applies flesh colors to the figures. The overall texture begins to look like sandblasted redwood: the accreted texture and irregularity he achieves through this impasto technique could be compared to spreading butter on a cracker.

We talk about Mark Tobey (his early social realism), the Barbizon painters; Currier's retracing of the steps of the proto-impressionist Jean-Baptiste Corot when he was in Narni, Italy. We talk about color.

"Probably the worst pigment I used to have on my palette was alizarin crimson. This was the most fugitive of all my colors until a couple of years ago; now Gamblin has developed a permanent alizarin. A color I miss is umber, which was only available from Umbria, Italy, where the vein ran out. A lot of manufacturers have been trying to reproduce it, but in my opinion no one has been able to. If I find a tube of old, pre-1970s umber, I always buy it—not that I use it so much in my palette now. Some of the most beautiful colors you can't find anymore, because a lot of them are still fugitive. Take alizarin-brown madder."

He achieves more and more texture and stacks of plateaus, which can only be seen close-up. Dipping and only partially mixing, he applies triads of color with the knife at each stroke. Now he is back in the yellow "tulip band," where the texture is thick and thicker—high-relief compared to the figures "down in a valley." There are random acts of color. He brings the bullet-shaped tulip marks closer and closer to the bottom of the painting, like the self-replicating matchsticks in Disney's *Sorcerer's Apprentice*—it's the "March of the Tulips."

He says these repetitive marks can get boring, but they are necessary. His tulip leaves are simple arrowheads. When he returns to the figures, the strokes/dollops are much finer than anticipated; he applies highlights, intensifies existing colors; nothing shocking but all necessary.

Waiting for the painting to cure a bit, Currier informs me he has felt inhibited; that under my gaze he was too controlled or manipulative. "It's a little flat."

From the side of the painting, I can now actually see the daubs and stacks of paint protruding like ornaments on a studded belt. Currier ties the space with a zig-zag of orange illumination meandering from the foreground through the figures, like a trail of volunteer hybrids of tulips and California poppies—improbable but satisfying.

This is the last sustained addition to the painting. Now as I compare it to other works in the room, I realize that Currier has slowly amplified the intensity and luminosity of the color, brought it up to the level of his prevalent style—not larger than life but somehow more vivid than life. It is as if he intended it to withstand ultimately even the greatest attacks of ultra-violet light.

Additionally, what I have not witnessed or shared, of course, is Currier's inner passion and reverie, as he has entered into the wordless, intuitive, and largely uncalculated process of mixing and applying paint. I can only guess about this, and I'm not even sure he has the words to explain this creative experience. For him, this has been the "art part." In effect, the painting is virtually finished without my having registered the exact moment; the realization comes to me that this is almost anticlimactic. I think of these recent days of demonstration and the "shifting of gears" it would take to look at the same painting in a frame on a gallery wall.

Last Frost, 2001, oil on canvas, 30 × 40 in. Collection of Jeffrey and Corinne Houpt

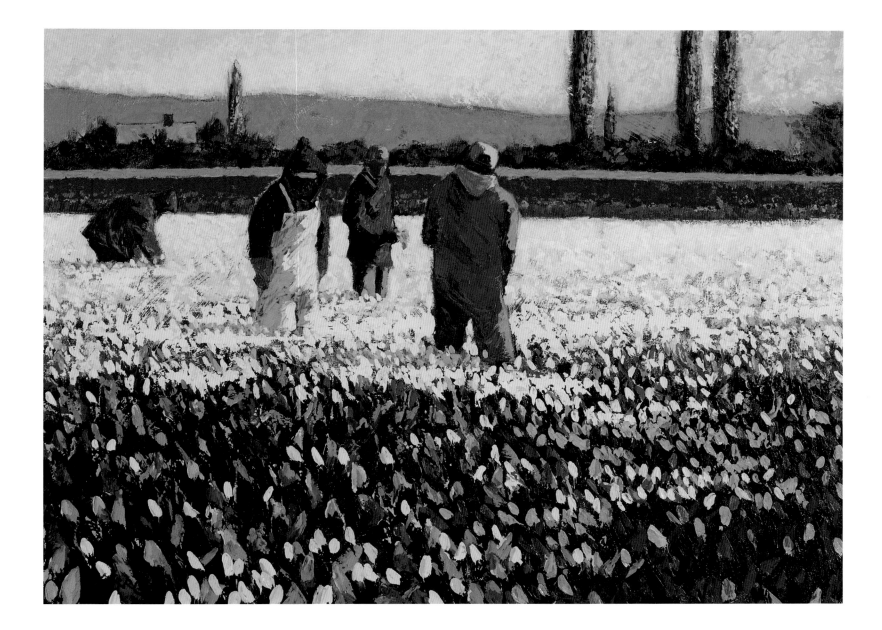

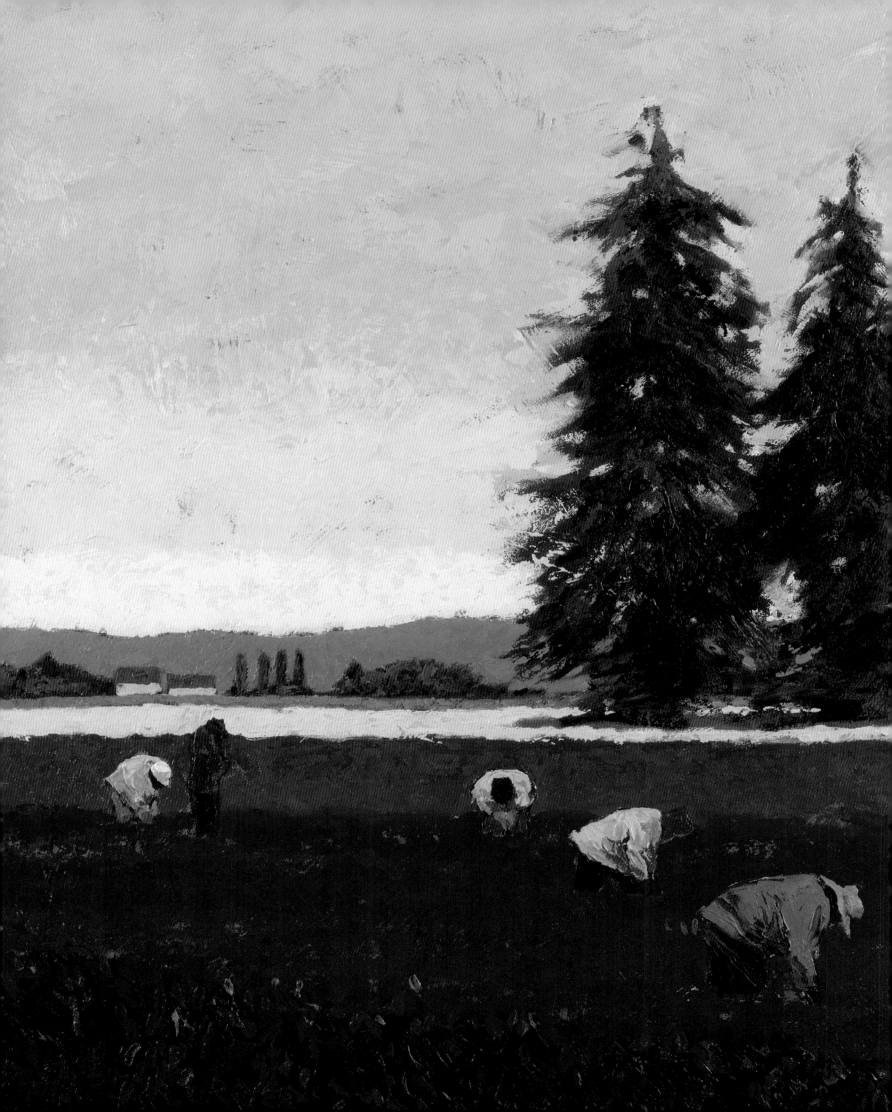

NOTES ON THE PAINTINGS

Alfred Currier's production over the past ten years, his most fruitful decade, netted roughly five hundred paintings and uncounted drawings. The latter are habitual, typically figurative: bodies bent or in some kind of tension, never posed, never portraits, as if he wishes to preserve their anonymity. Subjects appear oblivious to his gaze or have forgotten that he is holding a sketchbook and pencil. In line and shading, they are swiftly whittled into three-dimensional form.

Of this body of work, his paintings of tulip, iris, and daffodil fields dominate, but there are everyday scenes of Anacortes and Skagit County—ordinary backyards, lanes, work areas, homesteads—and forays into figure studies and studio life-drawings, always locked into satisfying, airtight compositions.

Currier also paints the occasional skyscape or seascape, addressing a radically different sense of fathomless space, without familiar signposts, boundaries, or strong figure/ground relationships. Here he depends on tone, color, and painterly surface to communicate. All art is illusory, but these works permit the viewer even greater leaps of the imagination, more extended moments of reverie.

The paintings that result from infrequent trips abroad take on an altered organizational character, conveying the relaxed quality of the travel experience. There are no exotic landscapes or monumental architecture, rather scenes of domestic life: taking meals, chatting, shopping, or relaxing in ways typically Italian or French or Mexican. These scenes are frequently arranged theatrically, as if framed in prosceniums; variegated building fronts contain shops, cafés, blinds, awnings. There are assorted props, and entrances and exits for the "actors." The scenes become a collagelike arrangement, for which a color décor has been to some extent invented, of shapes, surfaces, texture, and chiaroscuro through which a performance takes place.

Cedar Sky, 1998, oil on canvas, 36 × 36 in. Collection of Lynn Page and Chris Pinda-Allen

Of the representative paintings chosen to illustrate this book, a half-dozen or so general categories of subject area stand out and are arbitrarily titled: Domestic Scenes, Looking Out to Sea, Figurative, Still Lifes, Skyscapes, Scenes of Travel, and Tulip Fields. Brief impressions are offered, comparisons made, and analogies drawn. These selections are a guide to looking at Currier's oeuvre with fuller comprehension rather than an attempt to assign relative critical or material value.

Domestic Scenes

Currier's domestic scenes are exemplified by paintings such as *Quiet Time*. From the early 1990s, Currier demonstrated his ability to analyze a familiar backyard scene, divide it compositionally, and play it back in hunks of startling abstract impasto. In *Quiet Time* the central house and fence are laid out like laundered white linen in bright sun. Other house gables become receding "spear points." A broad violet shadow on the drive is intersected by a green "column" that directs the observer's eye to a yellowish building and the hazy swarm of gray-green trees in the far distance. Close up, when the components of this painting no longer resolve themselves into a picture of a modest Anacortes neighborhood, it is evident that the true subject of this picture is Currier's craft of color mixing and the aptness of each stroke.

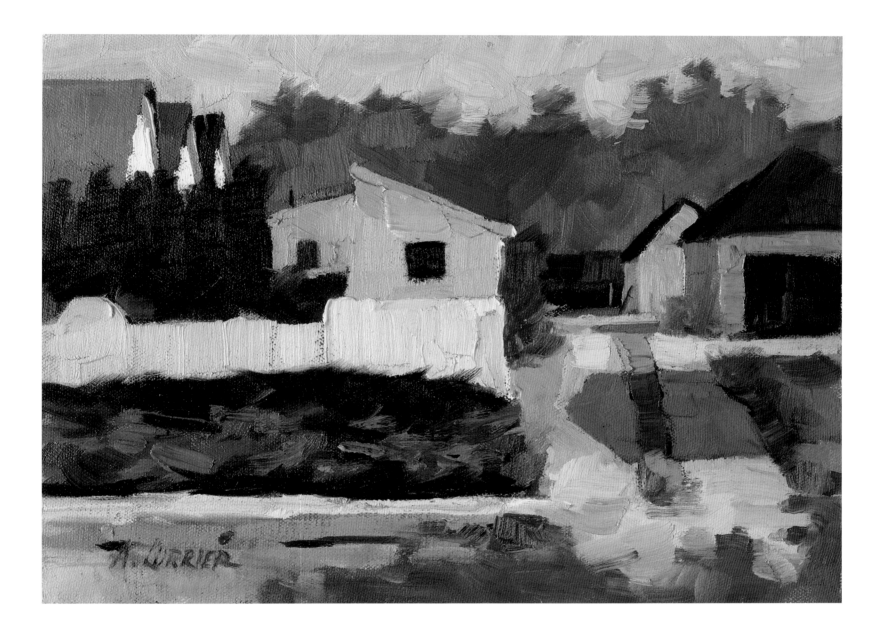

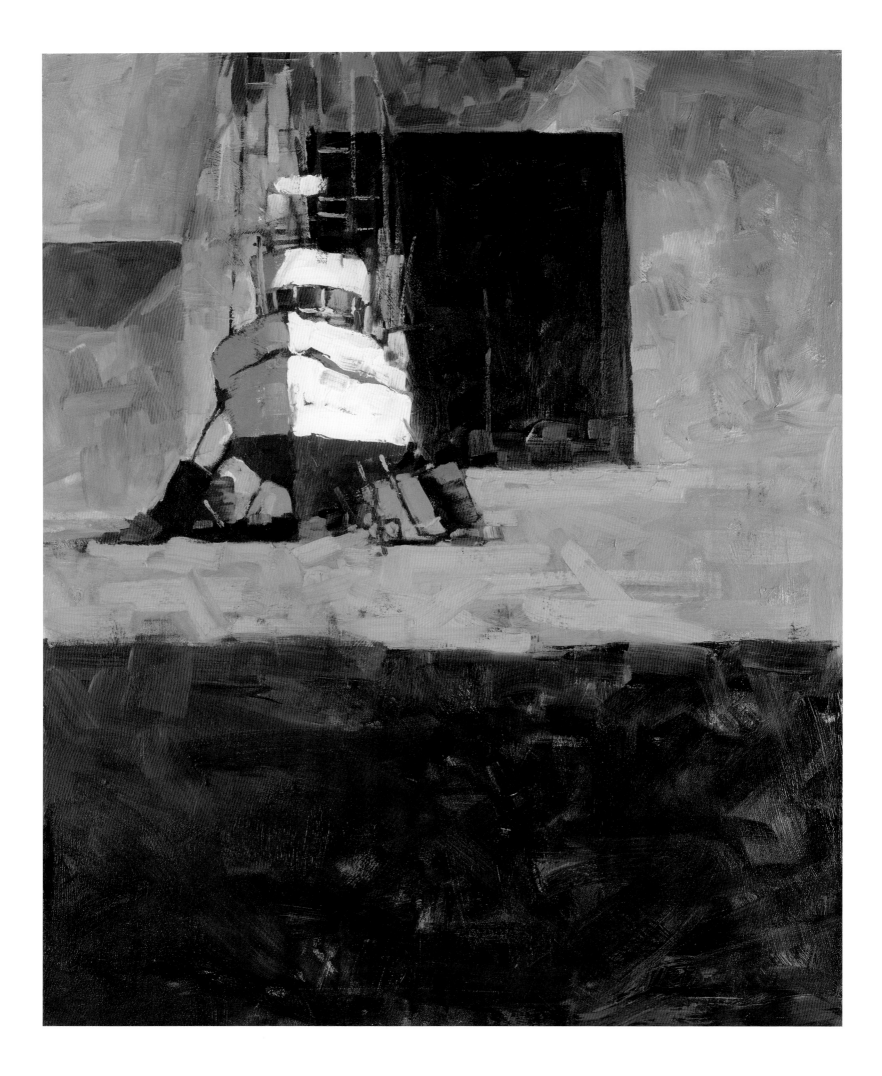

Resolute, 1993, oil on canvas,
30 × 24 in. Private collection

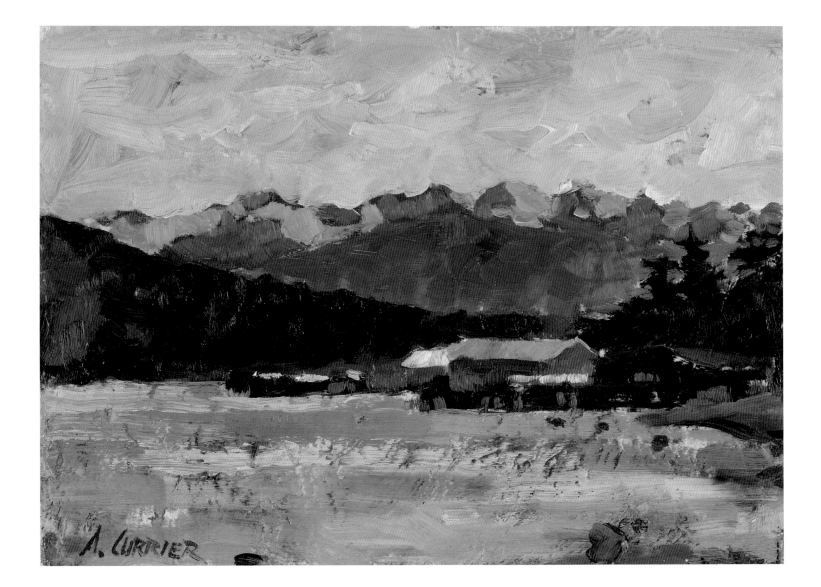

Cannery, 1995, oil on panel,
9 × 12 in. Collection of
Lewis Jones

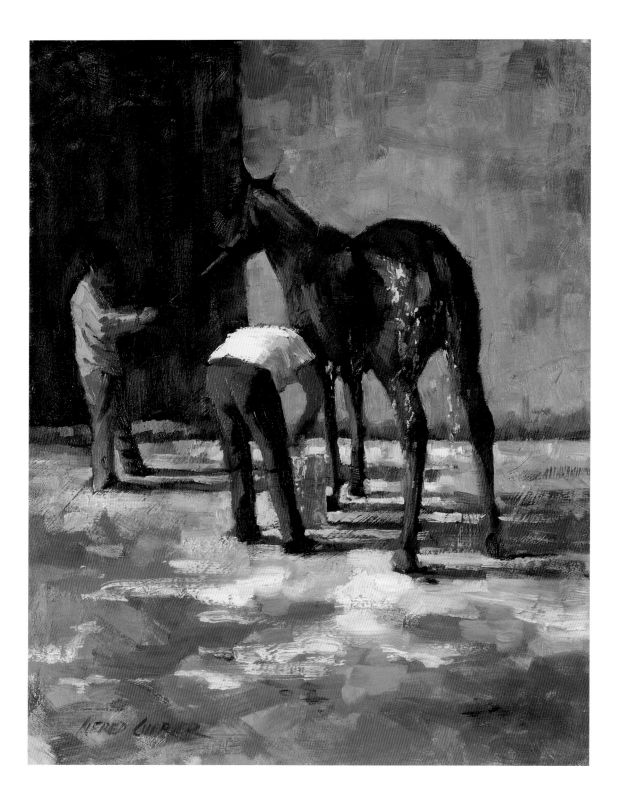

Washdown, 1988, oil on canvas, 24 × 18 in. Private collection

Back to the Barn, 1994, oil on
panel, 16 × 12 in. Private collection

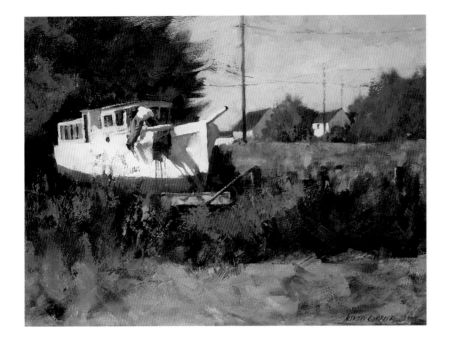

In another back-lot painting, *Summer Pleasure,* Currier tackles the complexities of
light and shadow and of shapes in space—and of solidly locking these elements into
a composition, keeping the observer aware of the separation between the planes
or objects. This is *tension:* the visual attraction or pull of the eye across the space.
Warm values dominate the central area, attracting our empathetic gaze, but it is the
cooler greens and blues that provide a color perspective while utility poles and house
ridges suggest a more defined linear perspective. The white boat with the red bottom
"floats" in this sea of painterly activity, hard edged and unequivocal. In the far dis-
tance, there is an overcast of cloud, but the pleasure Currier evokes in the painting
comes from the warmth of the middle ground and the human activity.

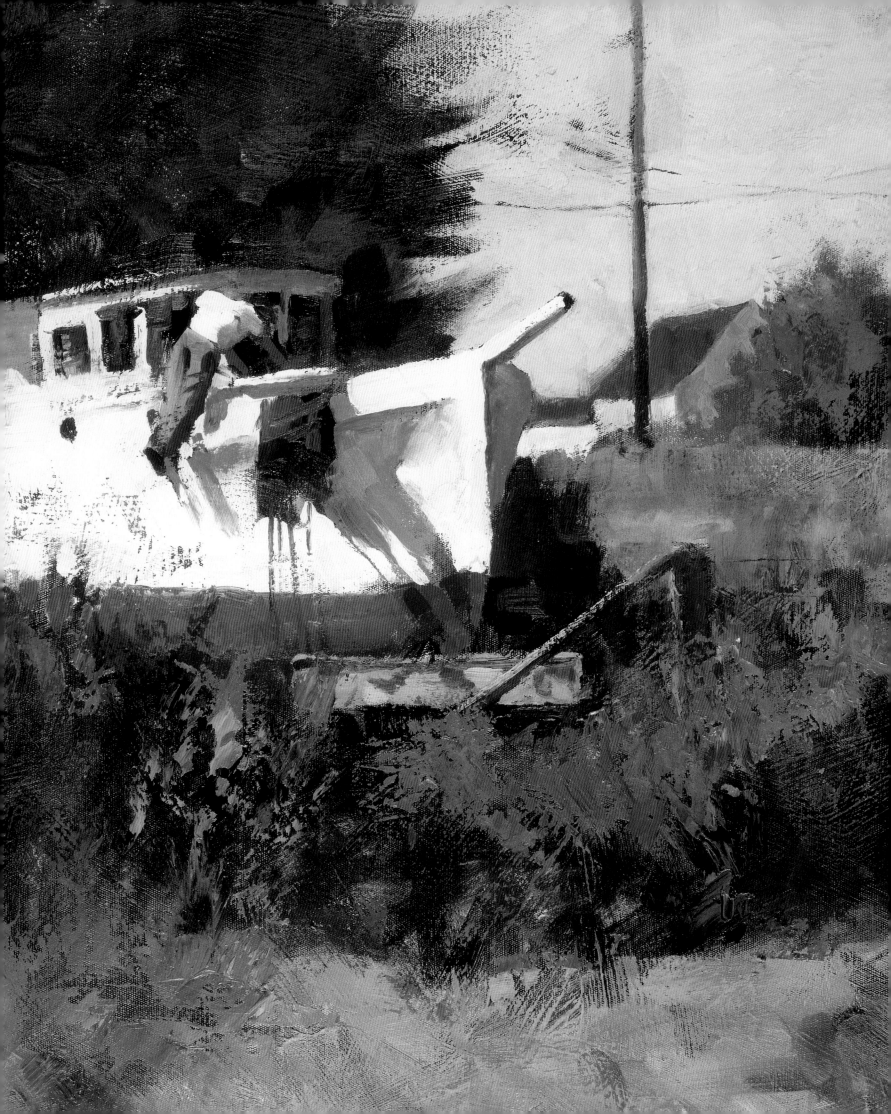

Looking Out to Sea

In *Whidbey Morning,* a white lighthouse with attached building may remind one of the intense light characteristically sought by the watercolorist Winslow Homer. This rare solar intensity receives Currier's ebullient response. *Summer Pleasure* (pages 40, 41) and *Resolute* (page 36), paintings in which he explores the always-difficult compound curves of boats, are also treated to this "Homerish" light.

Judging from its size and the directness of the application, *End of Ninth Motif #2* (page 44), is a plein-air painting. It is a view to open, golden water and sky, looking west in late afternoon when the sun over Puget Sound peeks out from under a blanket of overcast dominating a long winter day. Even now, there is a refraction of light into yellows and green over an underpainting of blue. Piles and layers of clouds, islands, and reflections appear in a dispassionate, phenomenological way—nature is its own painting, incapable of sentimentality or kitsch. Currier is not copying from nature; he interprets a brief moment in time and place before the dilution of memory.

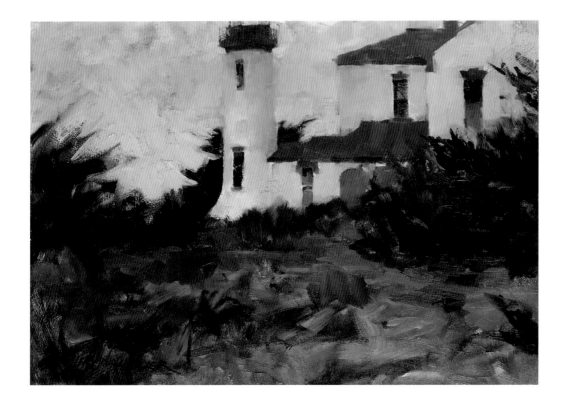

Whidbey Morning, 1995, oil on canvas, 18 × 24 in. Private collection

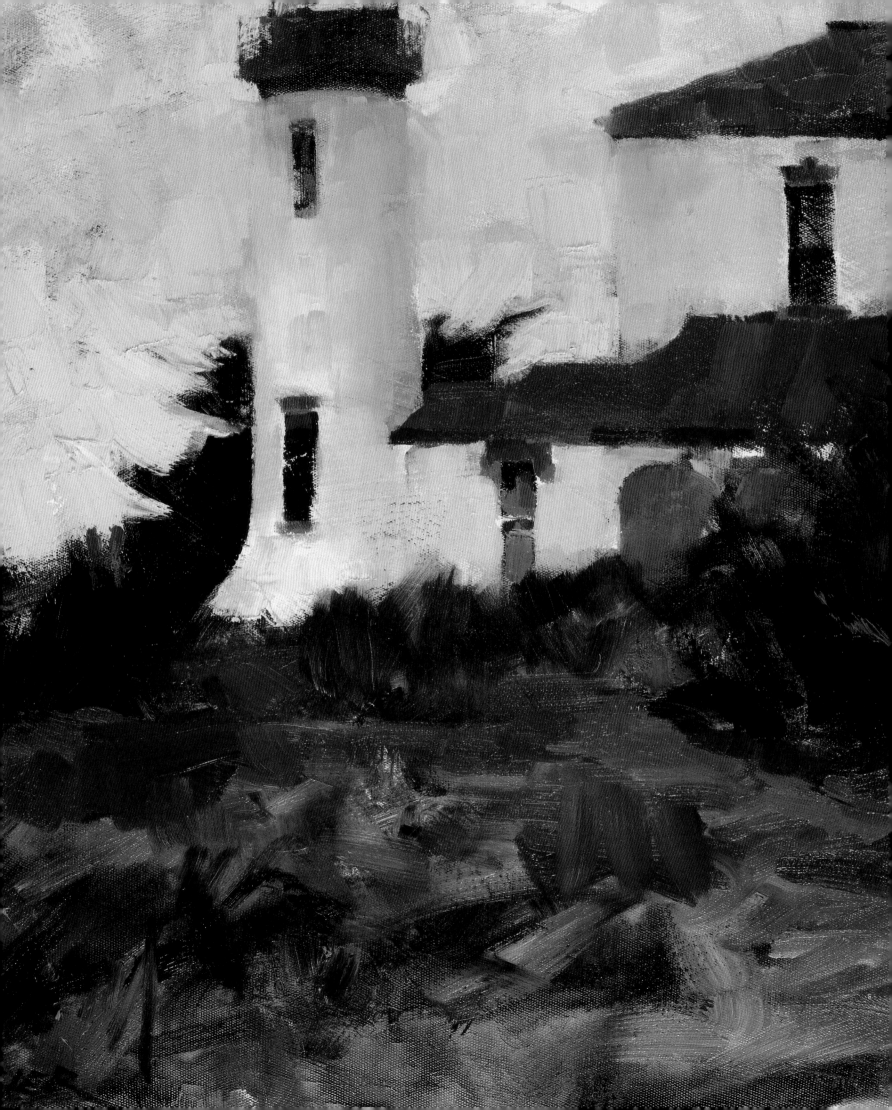

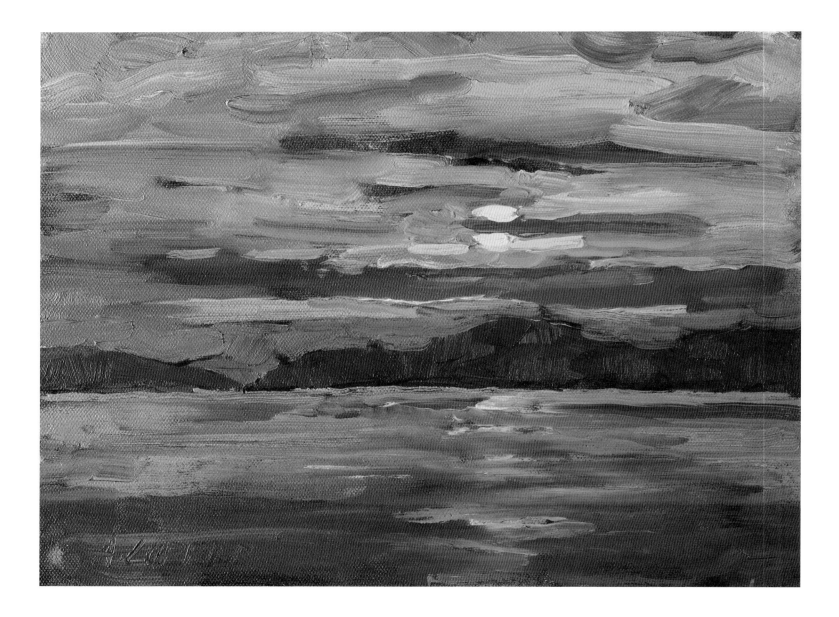

Burrows Bay, 1991, oil on
panel, 8 × 10 in. Collection
of Delphine Haley

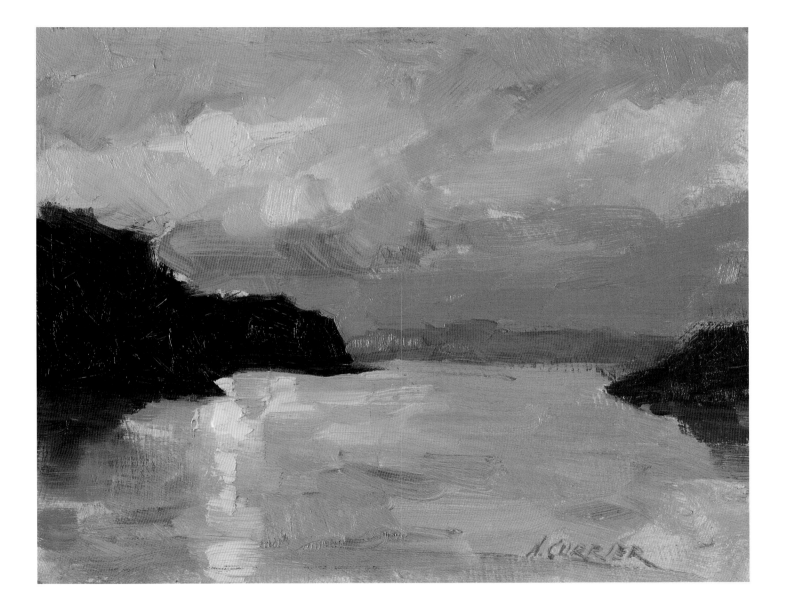

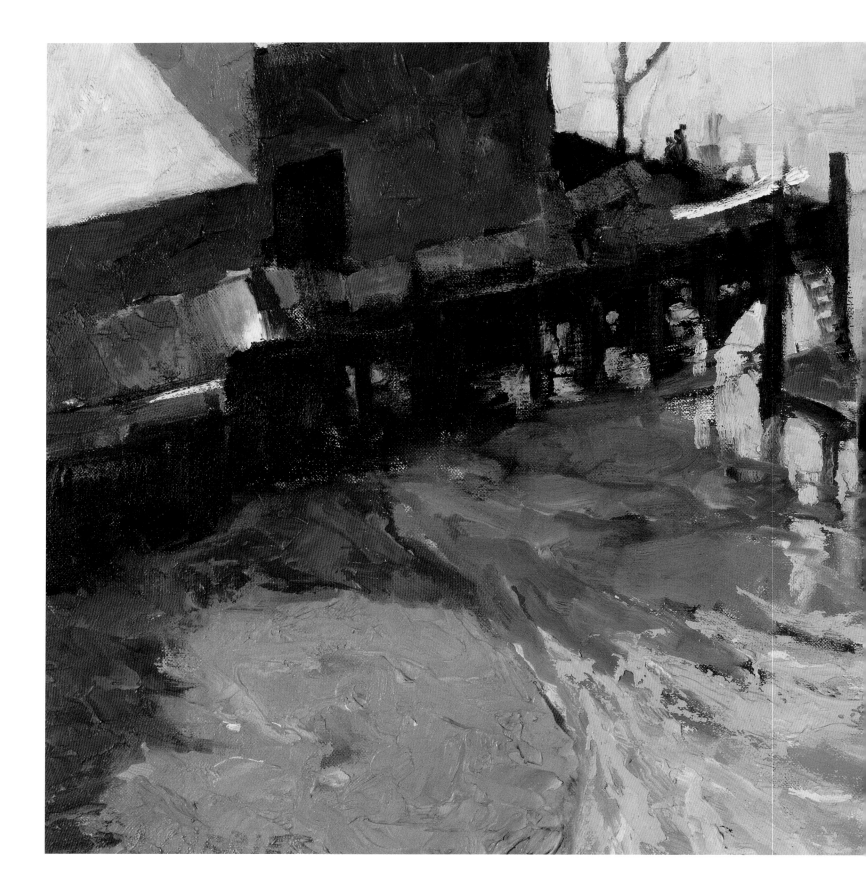

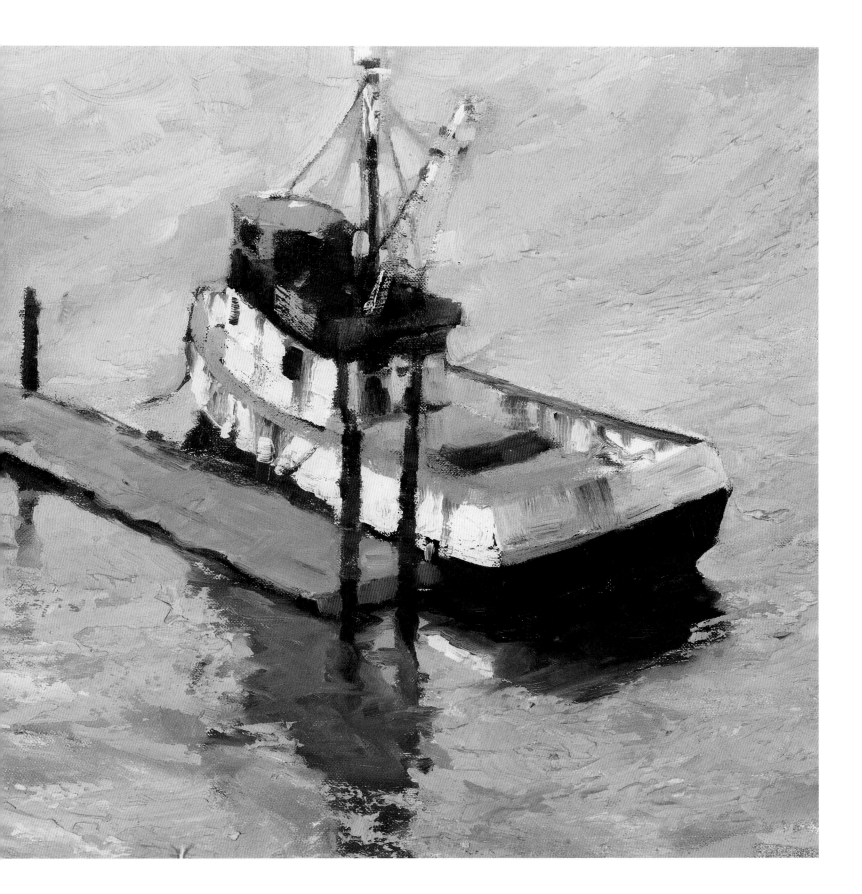

Channel View, 1996,
oil on canvas, 15 × 30 in.
Collection of Lin Folsom

Figurative

Titles can lend immediate ambiguity to a picture, as in *Impending Doom.* Is this crouching, sunburned towhead about to smash some creature in a tide pool? Or is a monstrous tidal wave ready to swallow him up? Note Currier's brush and impasto metaphors for hot sun on the child's tousled head and back. Rocks, swirls of tide-pool water, reflections, green slime—a painterly snapshot of earnest, youthful searching. The square-inch-by-square-inch detailing is amazing. The red outlining of the child's body and the red in his scalp are contrasted by the reflection of yellow and copper clouds and surrounded by the tensions set up in the movement of the water and the tautness of his skin and musculature. All this was done, Currier says, from drawings made on Fidalgo Island.

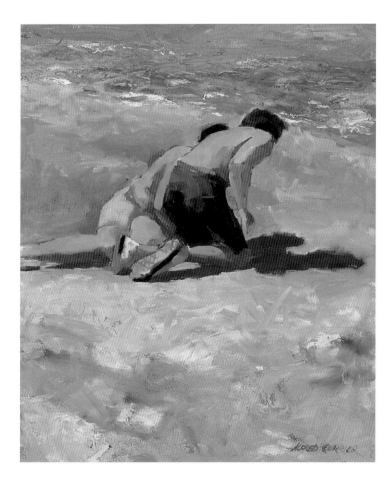

Formative Years, 1991, oil on canvas, 30 × 24 in. Collection of Roger and Lavon Mertens

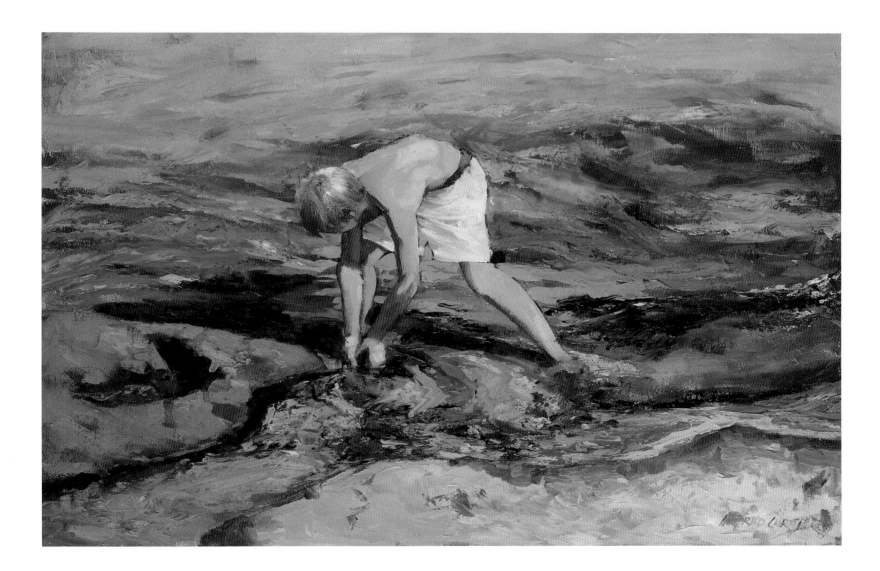

First Dig, 2001, oil on canvas,
36 × 60 in. Collection of Karen
and Neal Utz

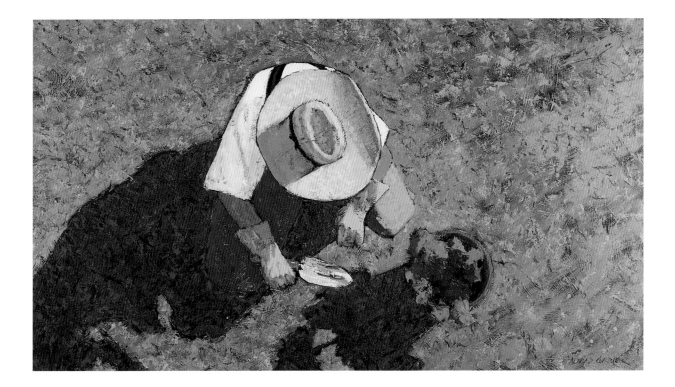

In *First Dig,* the figure is again crouching, and from the angle Currier has chosen—
and the foreshortening—the parts of the figure and the broad, bent straw hat are
broken into abstract shapes: a blue knee, yellow gloves, the white rectangle of a shirt
sleeve. Even the orange pot and red blossoms, seen from above, become a focal
design element. The entire ground, a pattern of orange and green knife strokes, is
applied randomly.

Study for *Smile,* 1999, oil on canvas, Collection of Marilynn and Dan Gottlieb

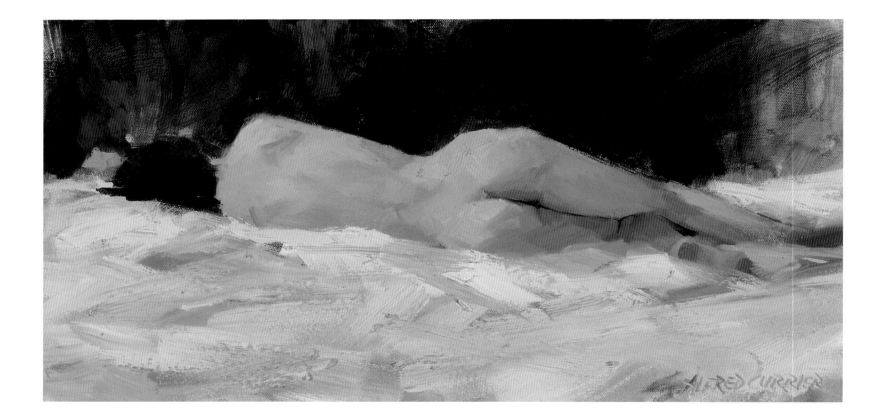

Sleeping Nude, 1998, oil on
canvas, 10 × 20 in. Collection
of Mitch and Linda Everton

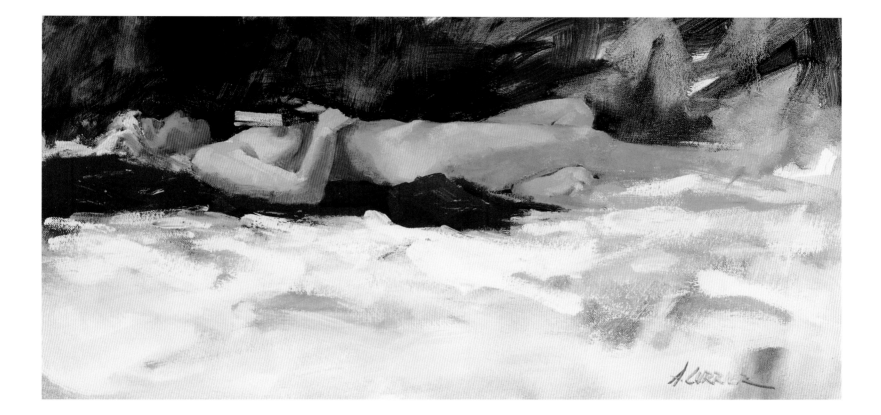

Still Lifes

Sunflower 3 is a studio-direct painting, one of a series worked up from a bunch of wilted sunflowers. Its style is art nouveau–ish (though art nouveau would insist on lush blossoms and healthy, sinuous stems). However, Currier demonstrates an important reality: in objective painting, there is no such thing as an inherently beautiful or ugly form, only light and contrast and what can be derived from them. Van Gogh wanted to distill searing color vibrations out of his sunflowers. Currier focuses on the technical problem of conveying the worthiness of abstract shapes and patterns from position and light.

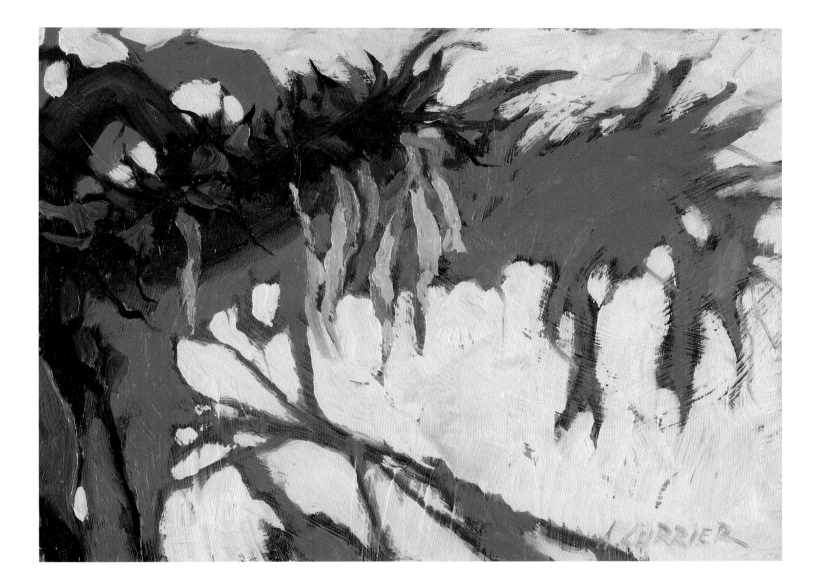

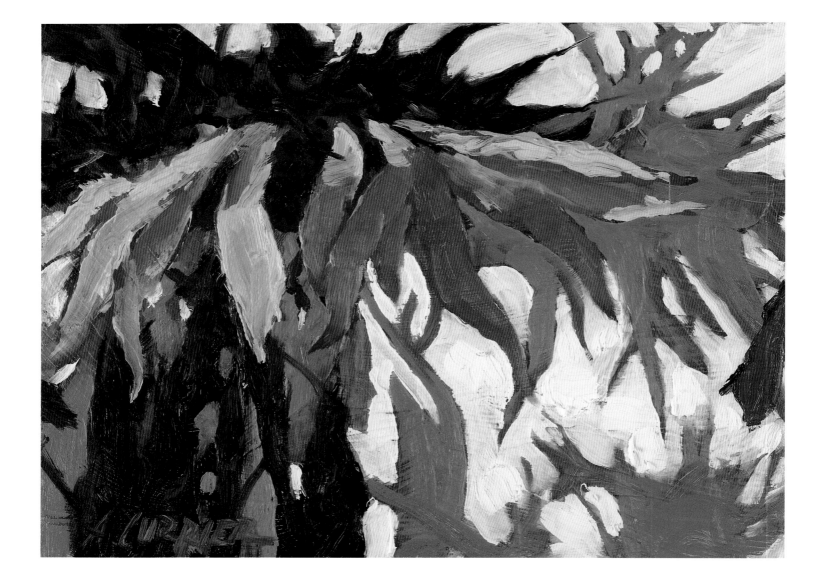

Sunflower 2, 1995, oil on panel,
9 × 12 in. Collection of Doug and
Nanci Allen

Yucca, 1990, oil on canvas,
18 × 14 in. Private collection

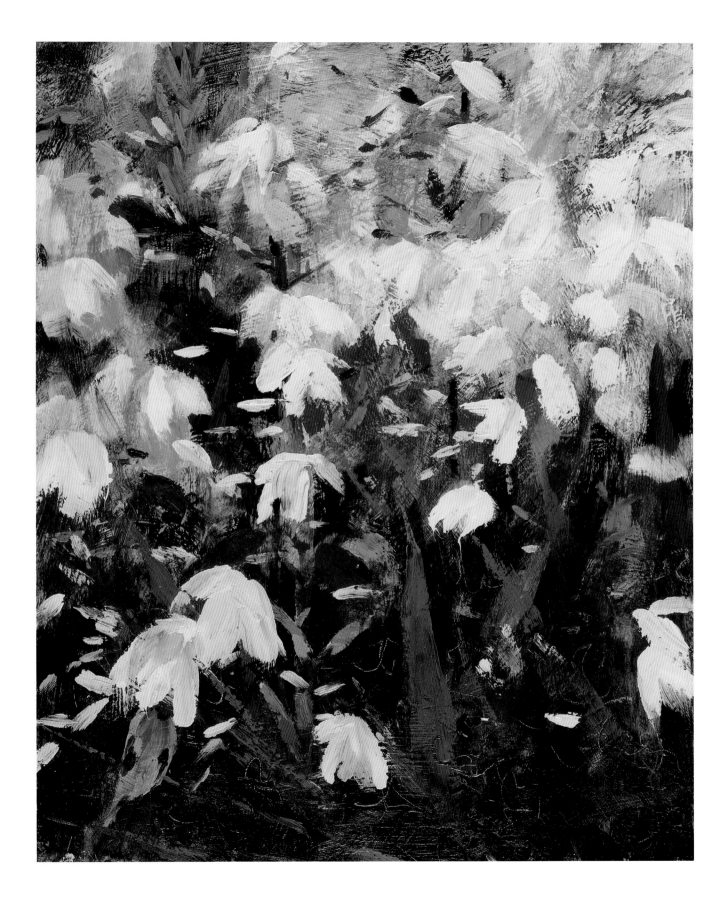

Skyscapes

In a vertical format, the angle of focus in *Lenticular Migration* is overtly turned to the sky, dominated by an almost seething pink cloud, with only a distant and red-rimmed horizon of hills and trees, placed very low, and a patch of blue at the upper right corner. This is the only "information" supplied by an otherwise abstract painting in which color, impasto, and duration of the activity are the primary concerns of the artist. Here he is at the edge of color-field painting. In a sense, the verticality of the painting disavows its intention as a landscape.

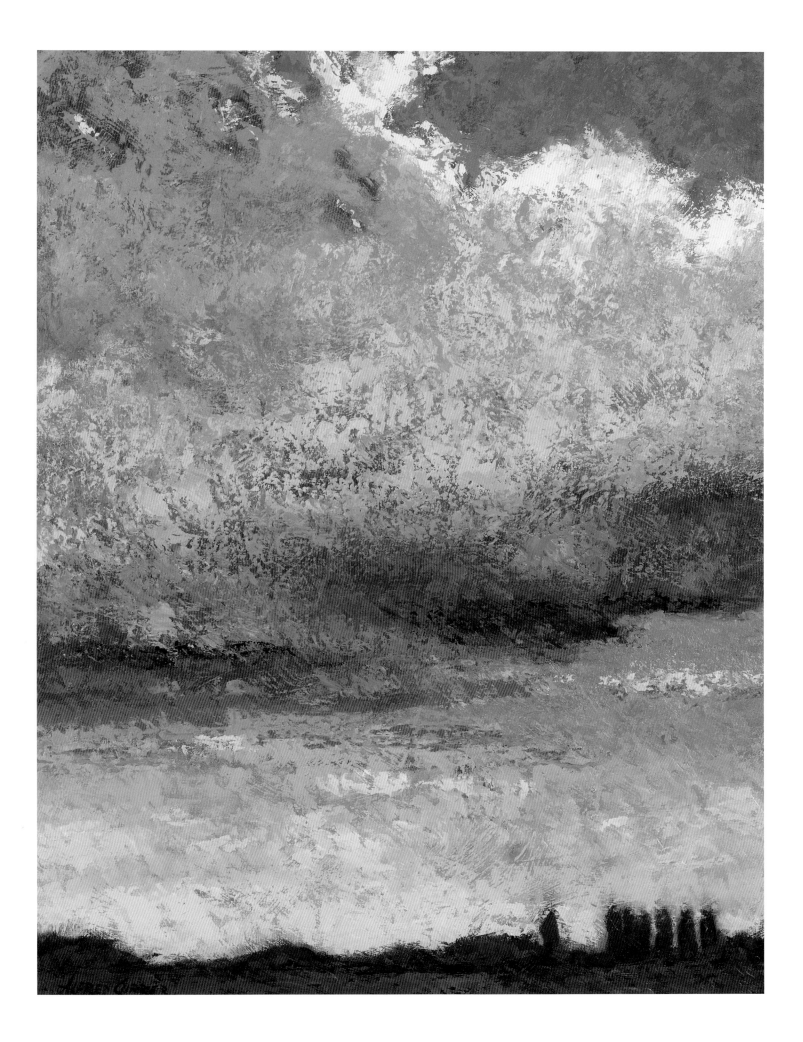

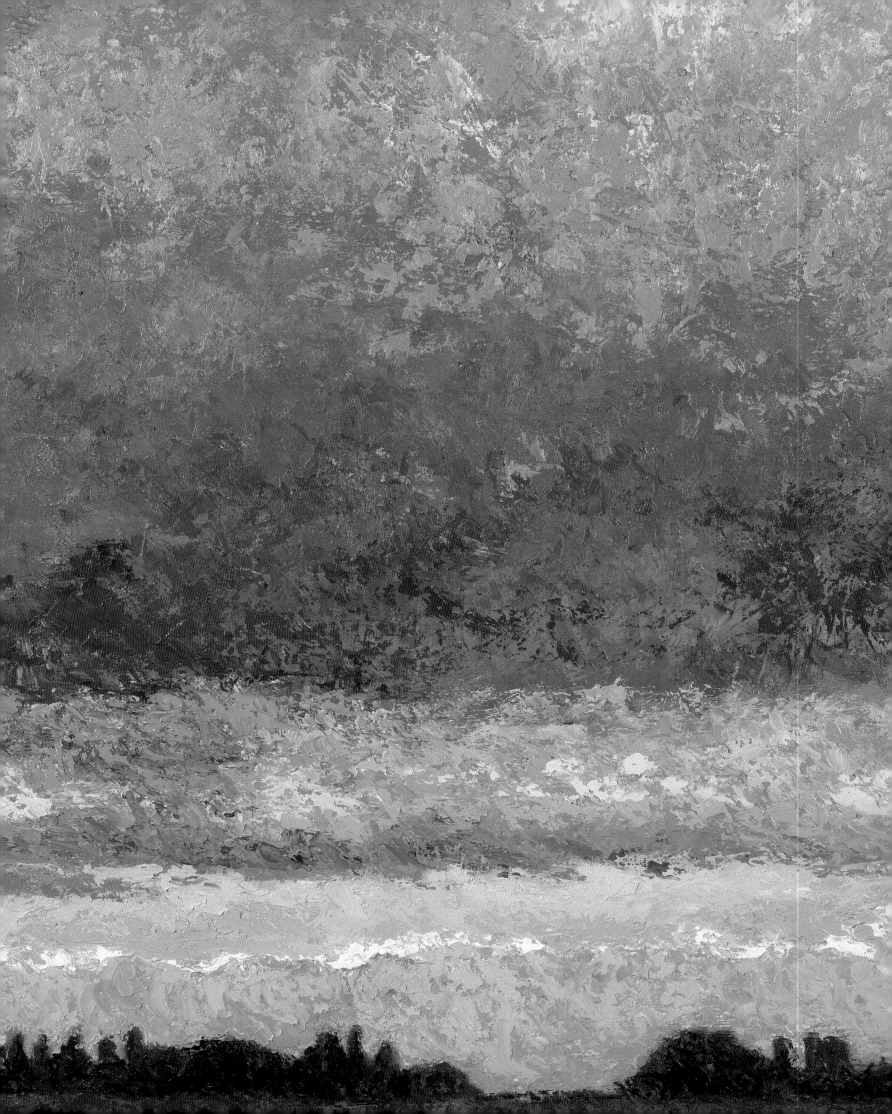

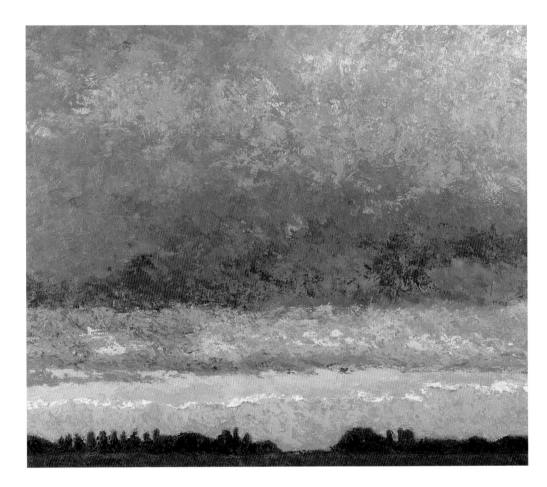

Temperance, 1995, oil on canvas,
40 × 44 in. Collection of
Dr. Regina Currier

Nor'wester, 1995, oil on canvas,
44 × 50 in. Collection of
Dr. Regina Currier

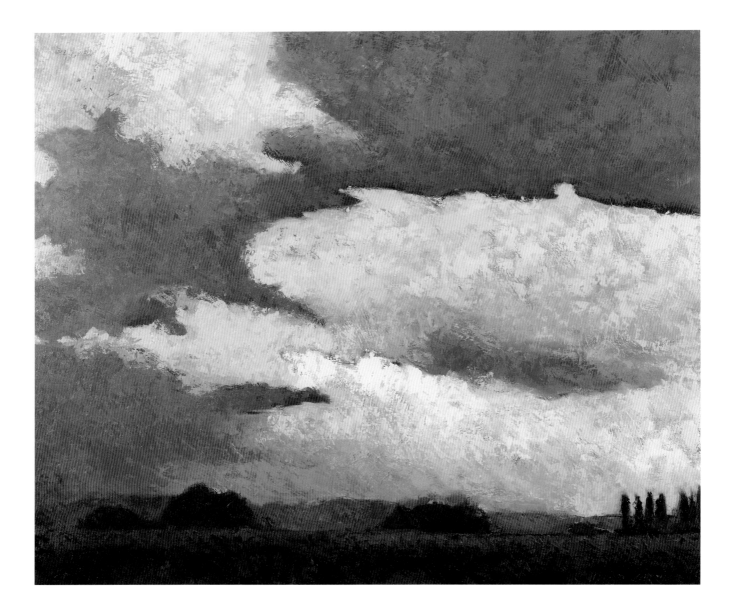

In another sky painting, *Nor'wester,* Currier underscores his need to capture the particular quality of Northwest light, the red qualities born of refraction. We are made aware of the enormity of the problem: painting the sky is like painting the sea in its infinite moods and guises. It is "painting the weather," from minute to minute; there is no end to it. As in *Lenticular Migration* (page 59), the sky takes up more than four-fifths of the composition, highlighting the fathomless space that Currier masterfully captures.

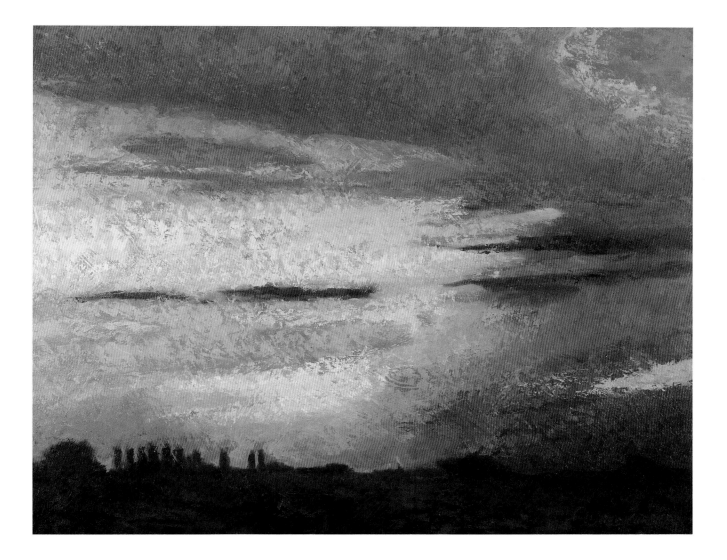

Scenes of Travel

In the category of Currier's European paintings, *Morning Walk* is an example of his proscenium style: arranged like the set of a colorful Italian operetta. The stacked house planes, laundry squares, boats, and walkers are reflected in a watery "orchestra pit." This is a balancing act of sharp and fuzzy detailing, like a Chinese sweet-and-sour dish. By Currier's standards, this is a large piece. It is also a moderately complex painting, in which the walker is central in a kaleidoscopic vortex of color and shape. Again, underlying reds predominate—either cadmium red deep or alizarin crimson (probably the latter, since he favors it). He needs the wide, watery foreground to achieve distance and anonymity for his subjects.

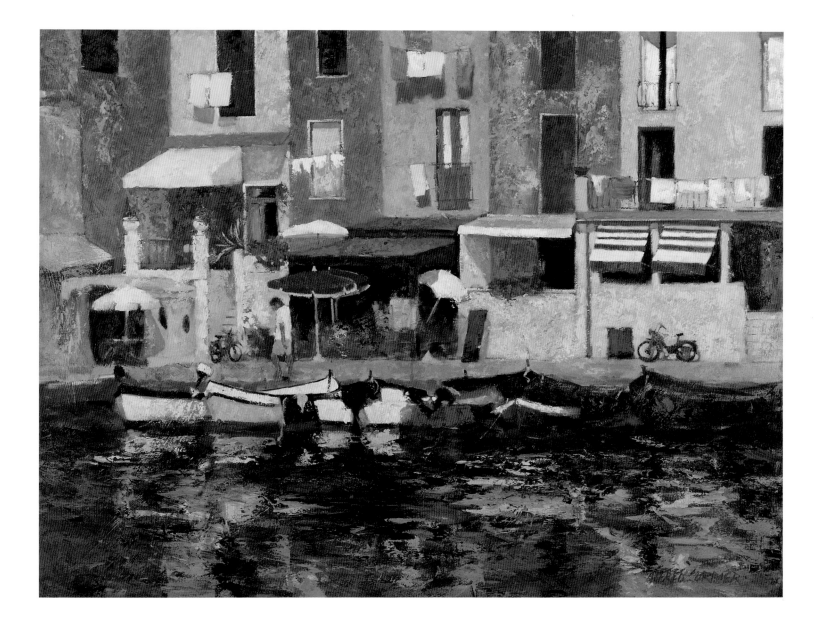

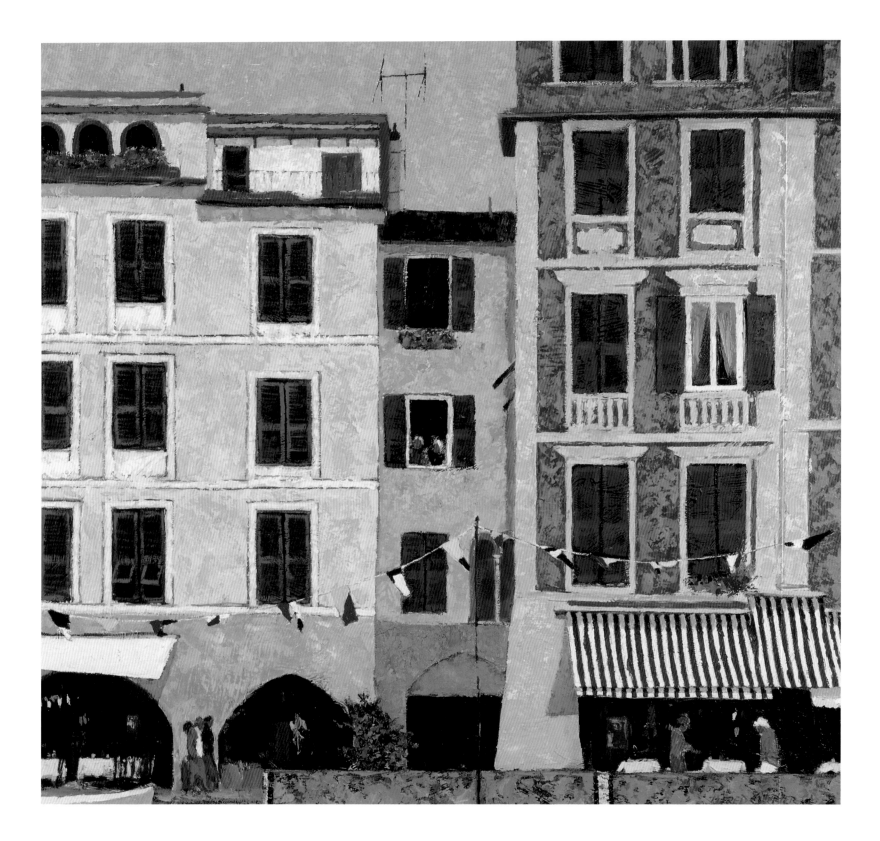

Andiamo, 1999, oil on canvas,
48 × 48 in. Collection of Mr. and
Mrs. Joseph E. Pendergast III

Bières, 1994, oil on canvas,
40 × 44 in. Collection of
Gwen and David Twyver

Assessment, 1999, oil on canvas,
35 × 36 in. Collection of Jim and
Sharon Kelleher

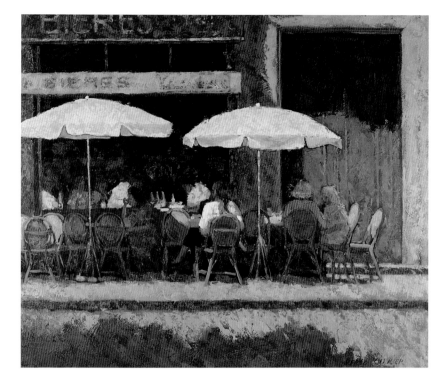

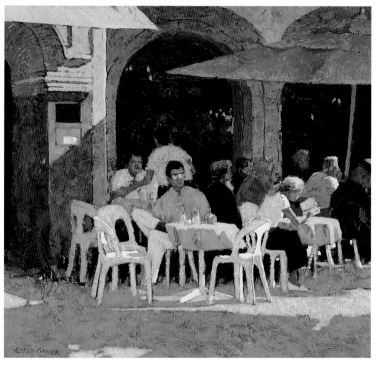

Other paintings reiterate this scene with exchanges of color or number of figures,
reductions or amplifications of scale, and so forth. Currier squeezes as much as
possible out of such a vivid experience. This repeated European theme, found in
such paintings as *Morning Walk, Andiamo, Assessment,* and *Suzzara* (pages 65,
66, 67, 68), perhaps marks the beginning of his serial work, where the elements
of a plein-air experience are transferred to a studio arsenal.

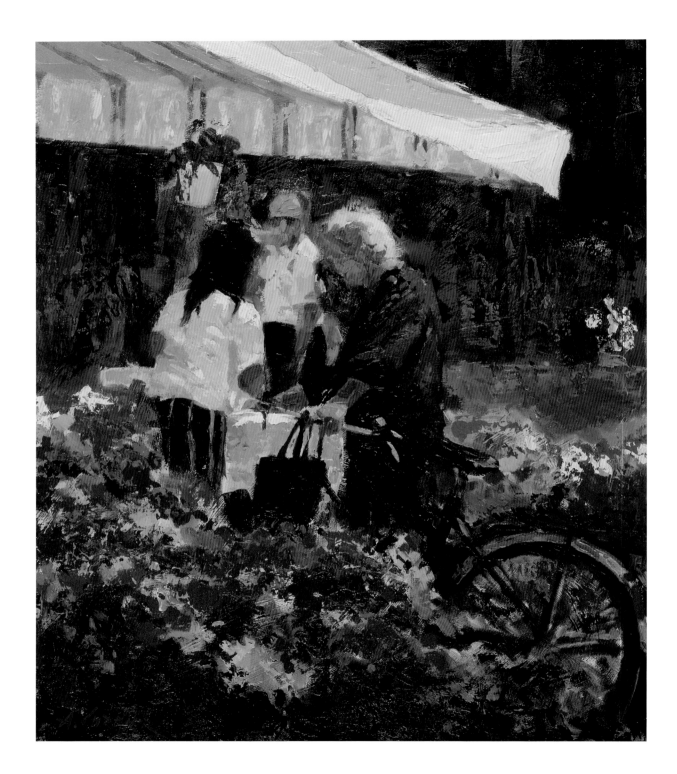

Suzzara, 1997, oil on canvas,
24 × 20 in. Collection of
Mary Kitts

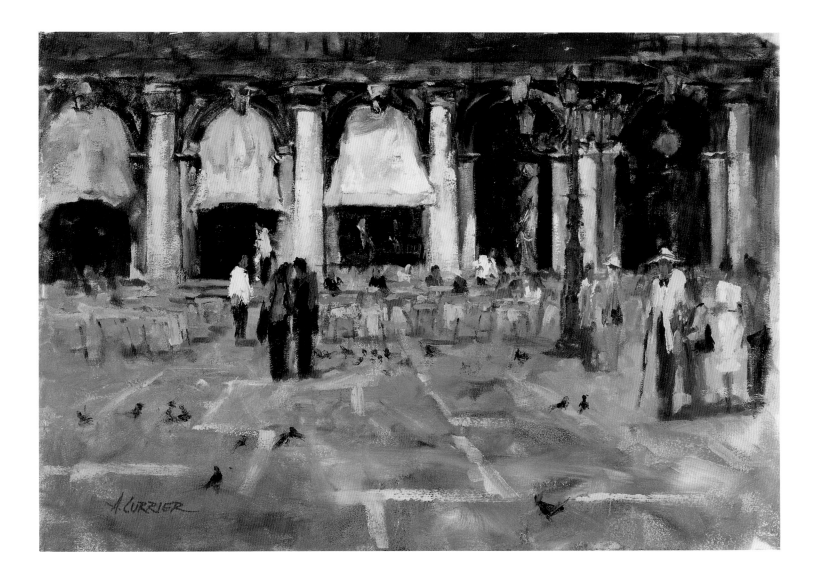

Venezia, 1997, oil on canvas,
16 × 22 in. Collection of Mr. and
Mrs. Paul Luvera

Bières, Revisited, 2001,
oil on canvas, 36 × 48 in.
Private collection

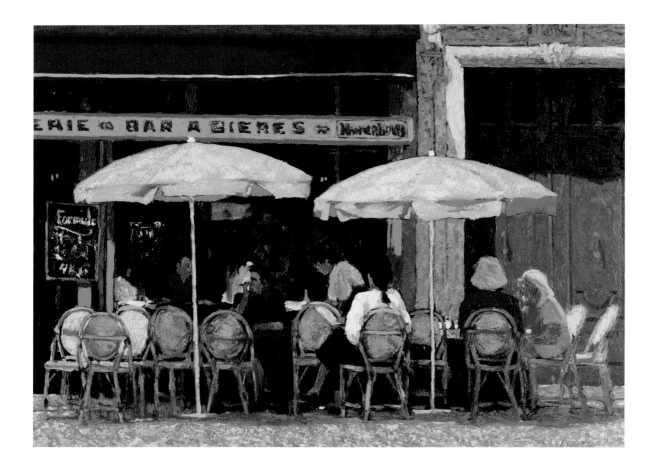

Bières, Revisited suggests the possibilities of generations emanating from the same image and again points up the true focus of the artist in the process of painting. The red proscenium, yellow umbrellas, faded green door, and bentwood chairs; the simple paint-daub figures with their red, white, and blue blouses; the blue-black interior of the café with highlights of interior figures, simply reflections from bare skin—all are reversible elements in this floating operetta.

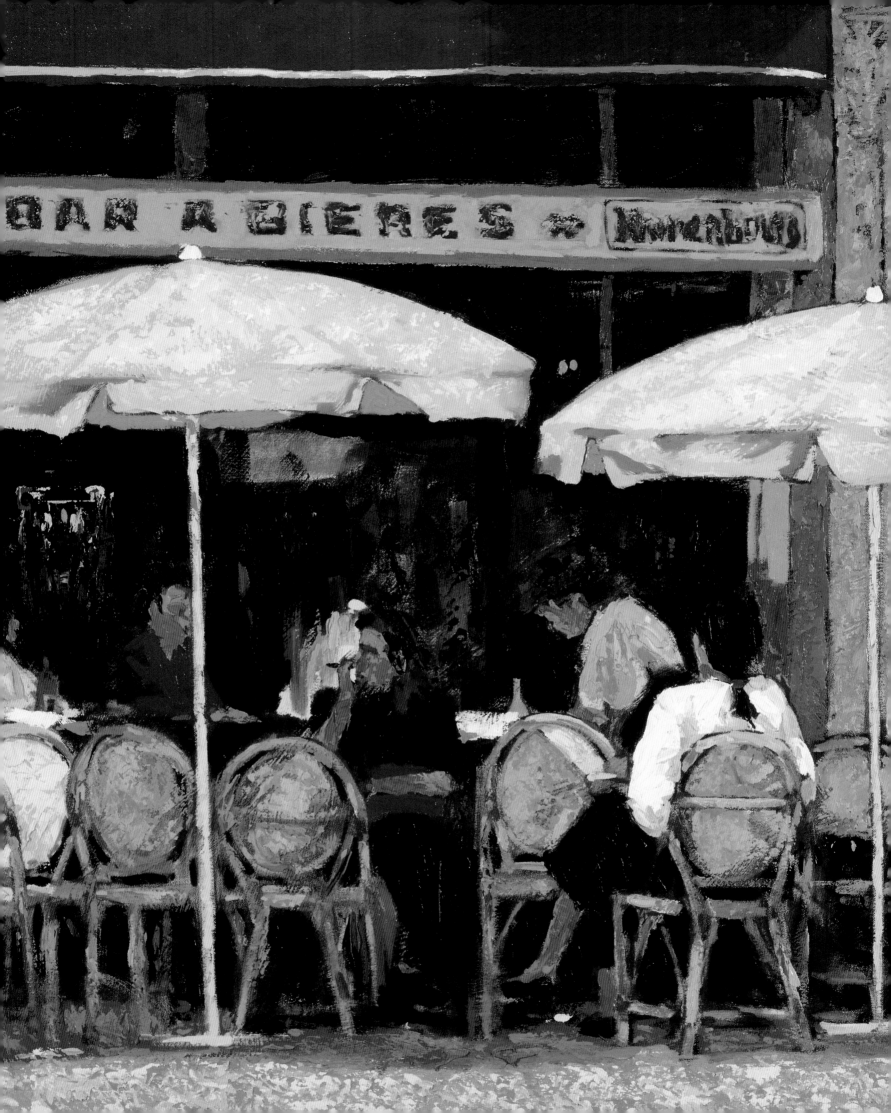

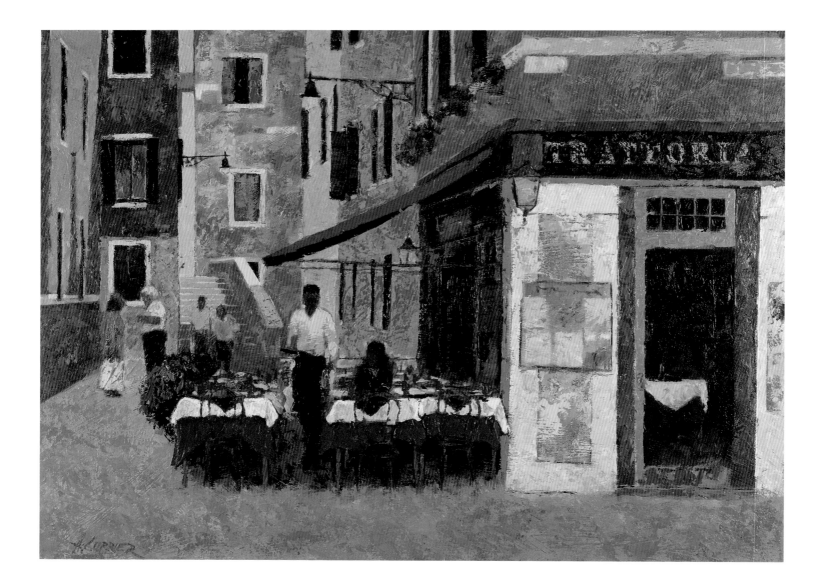

Trattoria, 1996, oil on canvas, 30 × 40 in. Collection of Tim and Kara Sullivan

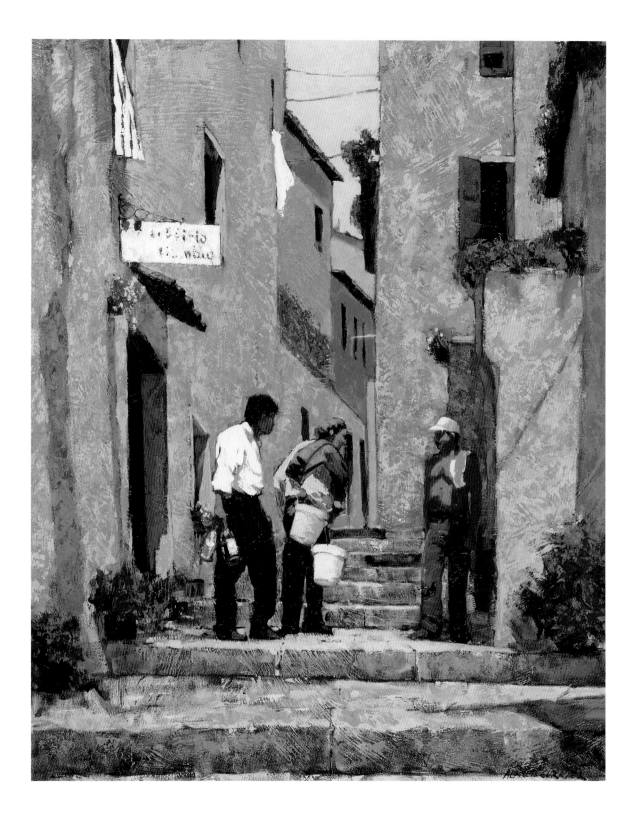

Cugini, 2000, oil on canvas,
40 × 30 in. Collection of Kari
and Dr. Nate Barrett

Flea Market, 1994, oil on canvas, 48 × 36 in. Collection of Ann Blake

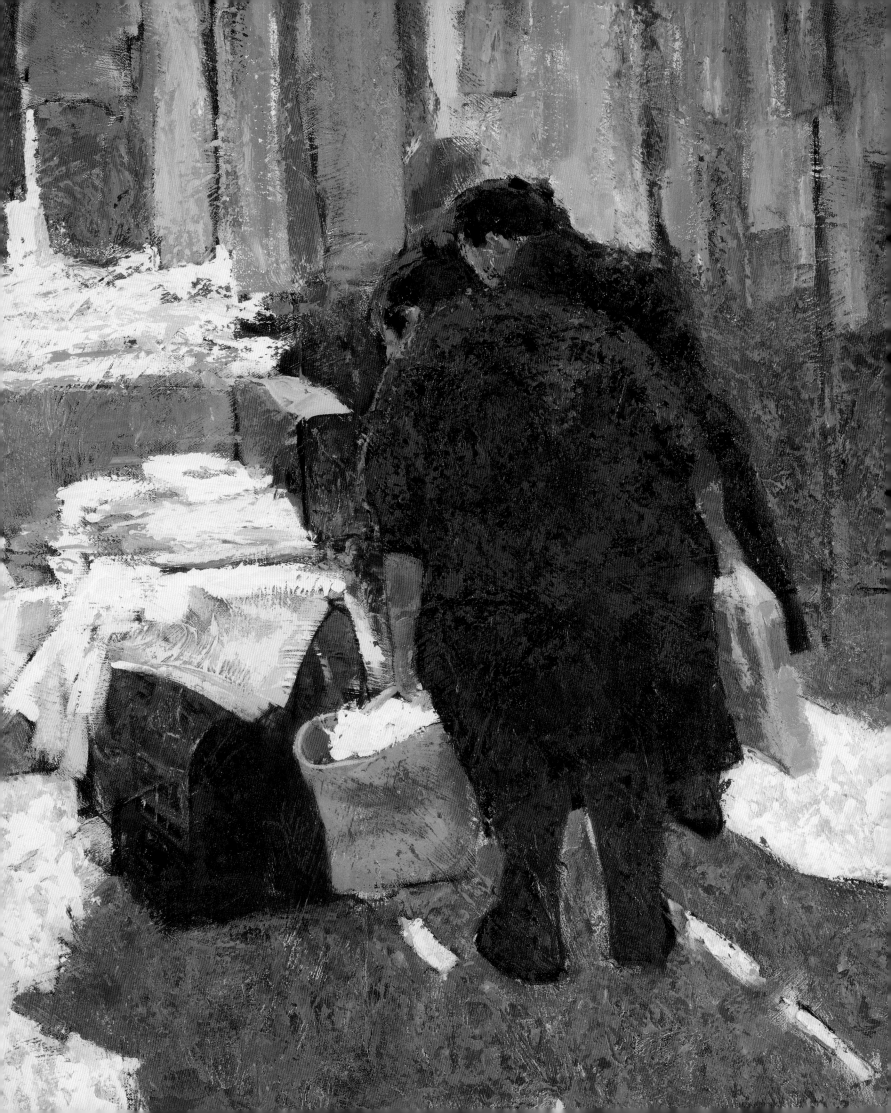

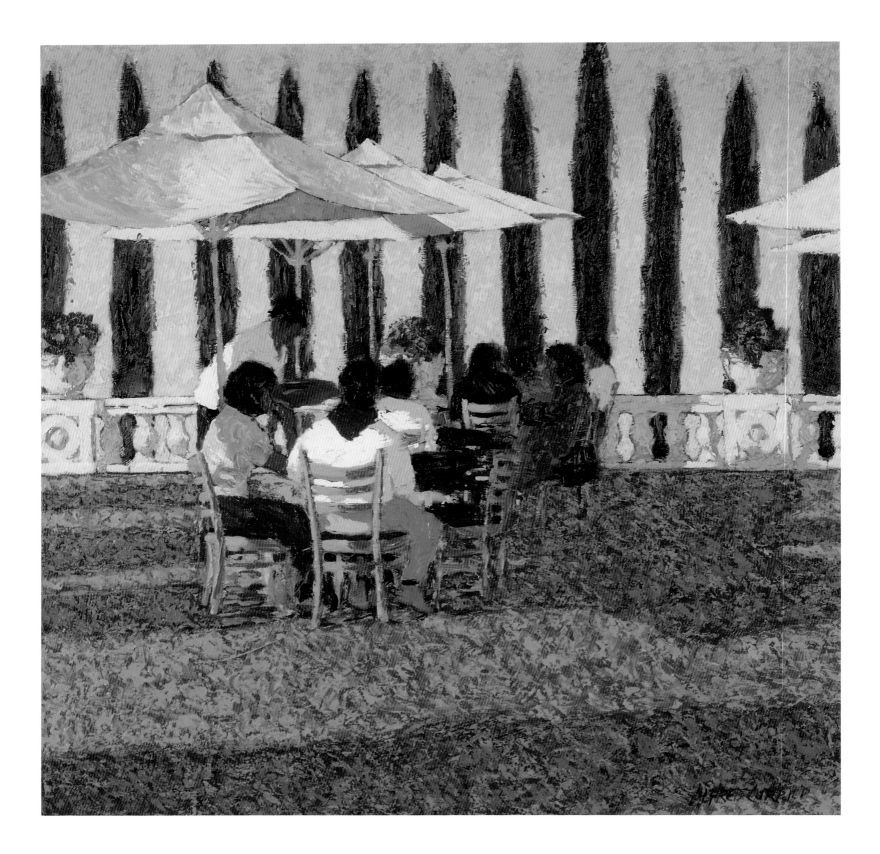

Viaggio Italiano, 1998, oil on canvas, 36 × 36 in. Collection of Mitch and Linda Everton

Suzzara Color, 2001, oil on
canvas, 36 × 36 in. Collection
of Matt and Kathleen Brown

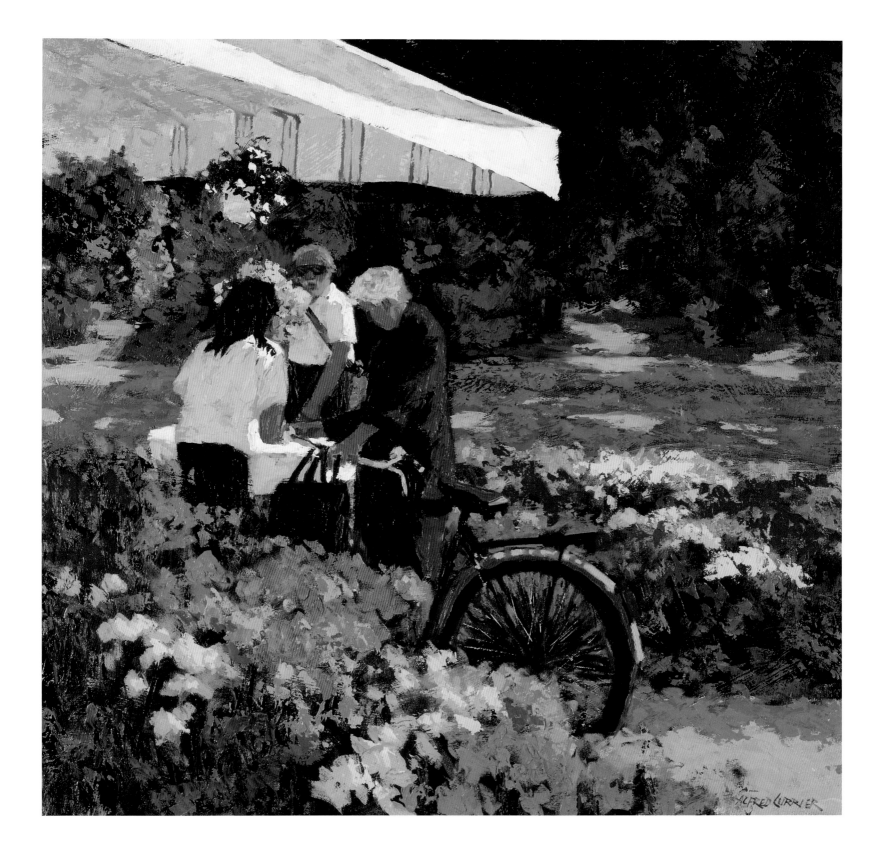

Hermanas, 1994, oil on canvas,
48 × 48 in. Collection of
Alice Christoph

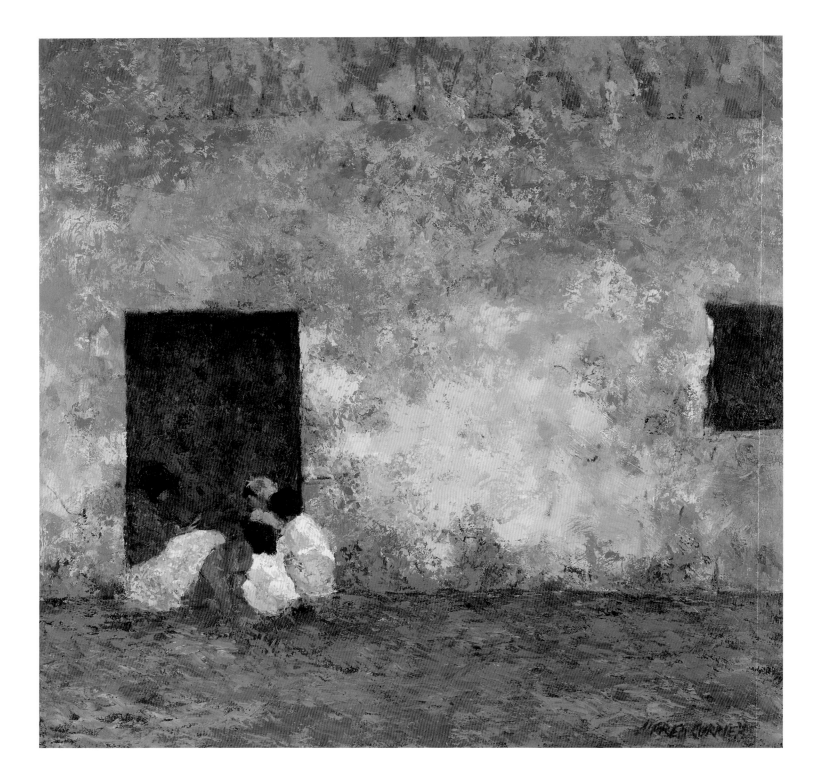

Mercado, 1993, oil on canvas,
36 × 40 in. Collection of
Janet Henson

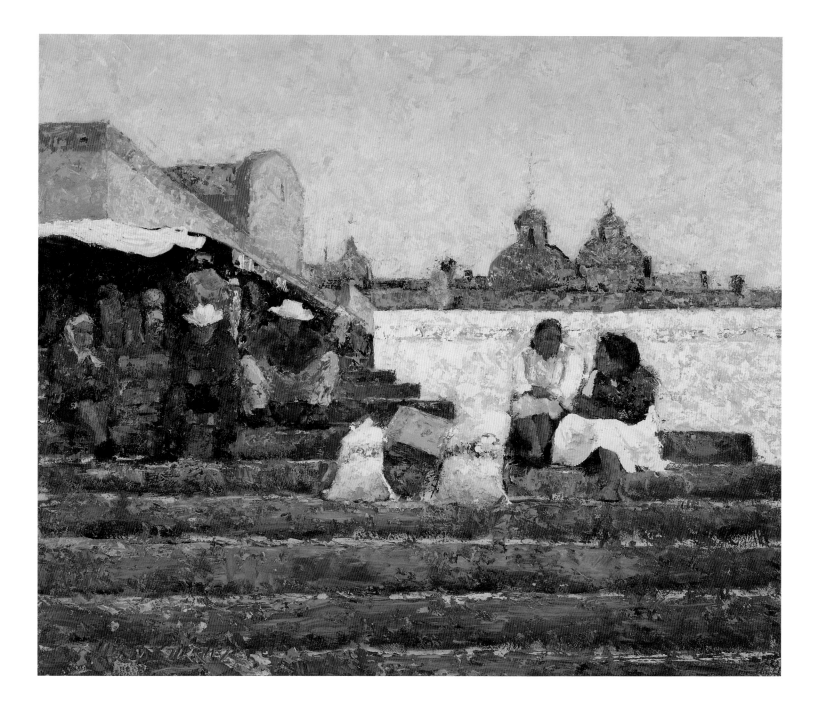

Tulip Fields

Distinguishing the differences in Currier's serial tulip-field paintings by saying, for instance, "This one has seven poplars and six *braceros*," misses the point. Viewed individually they reveal far more subtle and provocative comparisons: in the combinations of value that the artist has achieved by systematically dipping his brush or paint knife into piles or dollops of palette paint; in reflecting (as part of the process) his symbiotic response to music, his transient mood; and in concentrating on building the dense phrases of an almost calligraphic line. Looked at collectively (which always raises issues not necessarily intended by the artist, who paints the pictures one at a time) there is still a substantial range of discernible "presences," temperatures, depths of vision, and stylistic flourishes to be sorted out.

Tulip Harvest contains two bending figures, one with the familiar broad straw hat. An earlier tulip-field painting, the handling is unlike his more recent work; rather than the later arrowheads, the blossoms are abstracted to something like full-blown hollyhocks, with more developed flowers and leaves. In each case he adopts a specific brush or knife mark to stand in for the myriad blooms. But Currier can never be a complete literalist, taking painterly liberties here rendering flowers almost past their prime. The surface appears to be brushed impasto with a lot of under-texture, which shows through in the center of the composition. This is not quite his present style with this subject matter. It is as brilliant in chroma but not as sharply compartmentalized or as boldly mannerist.

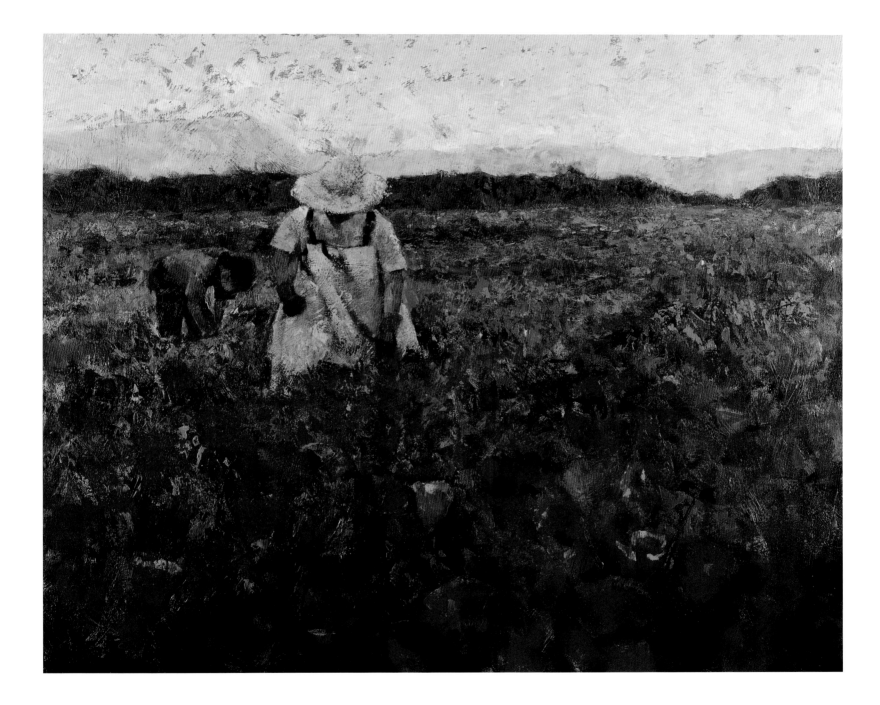

Tulip Harvest, 1992, oil on canvas, 40 × 44 in. Private collection

By comparison *Primary Colors* is a vibrant painting that bears out what has become Currier's absolute signature style, his repertoire of color and space intervals. Curiously, there are no figures, his typical jumping off point into surrounding space. So where did he start? With the lazy S-curve of the slough? Or the dense "ropes" of sedge and tule along the water? Sentinal poplars march in from the right; ragged, more distant firs match the broken patterns of blue sky visible through soaring strands of pink cloud. Quickly, the whole visual orchestration performs in an atmosphere of silence and serenity. Everything is in repose.

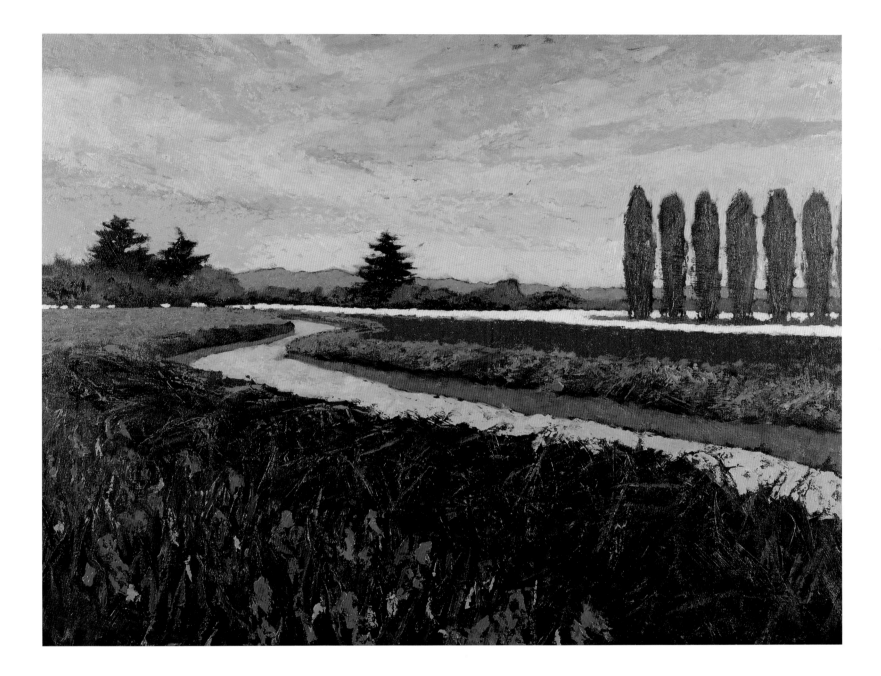

Primary Colors, 1997, oil on canvas, 40 × 50 in. Private collection

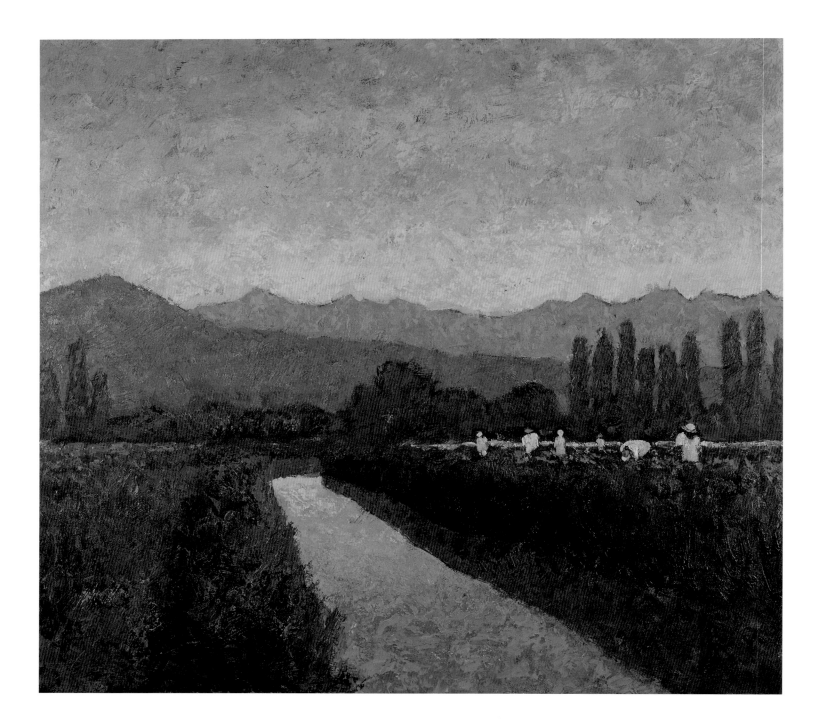

Lifting, 1994, oil on canvas,
44 × 50 in. Private collection

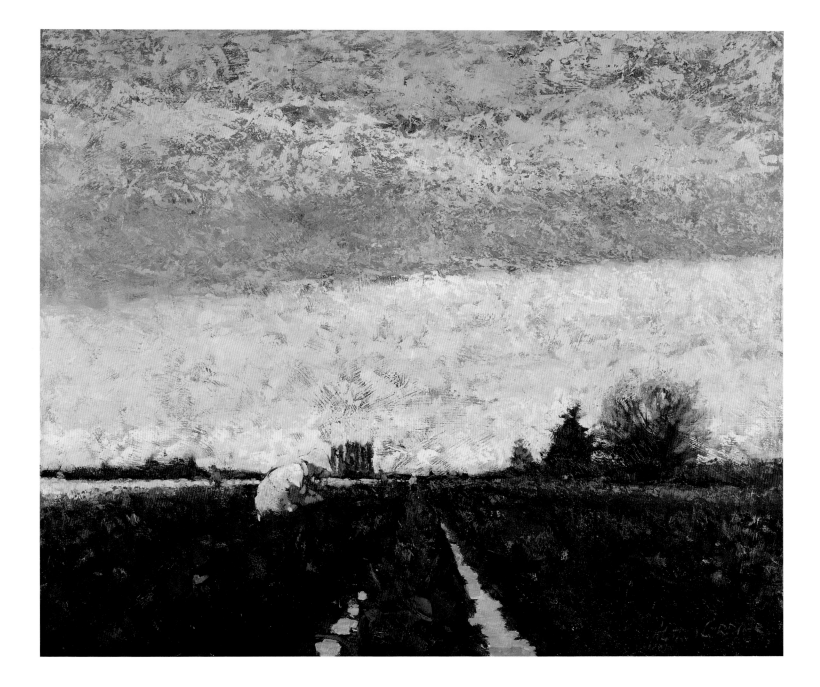

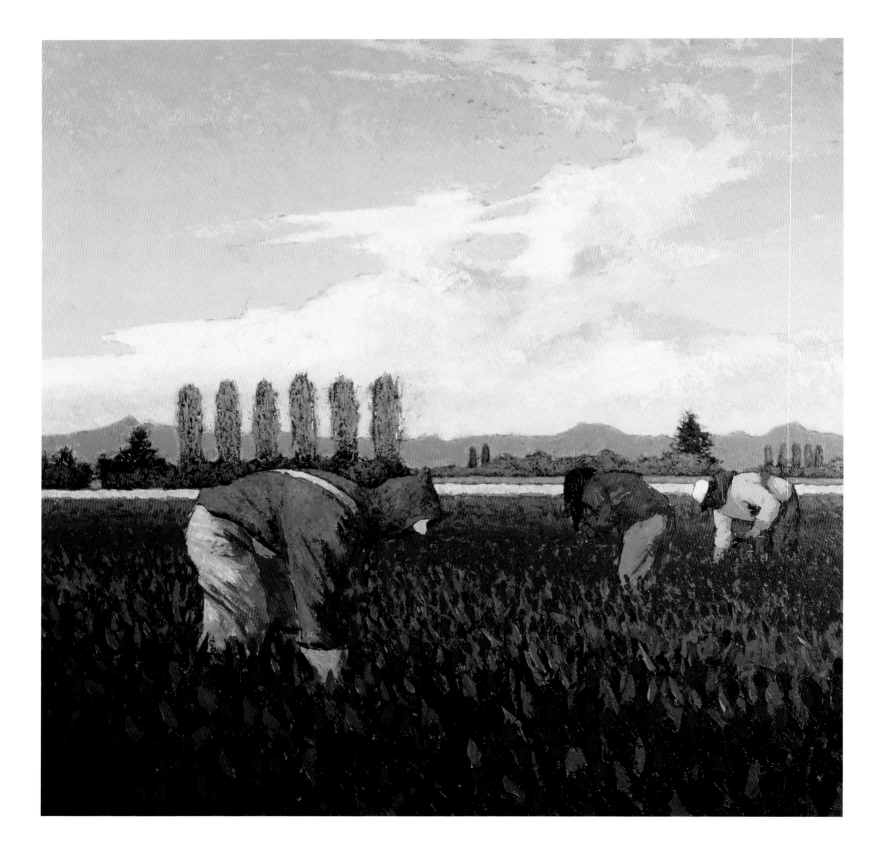

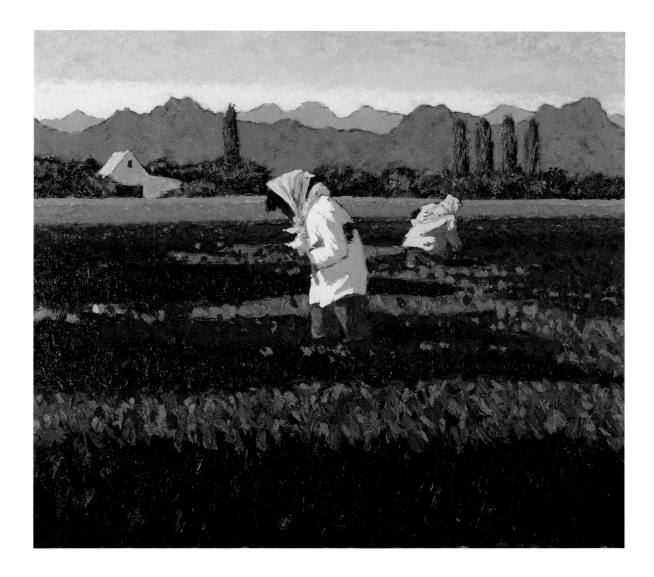

The title *Valley Pride* sounds like the logo from a California fruit-box label. From this date on, endlessly toiling field-workers are a constant presence in Currier's tulip-field paintings, as much part of the landscape as the poplars or the distant mountain-forms. In paintings like this one, Currier's color becomes almost epic. And it is now a wholly invented color rather than a naturalistic one. Many of these genre paintings are composed of primary colors—red, yellow, and blue—with secondary hues—orange, green, and violet—a close second, followed by tertiary hues such as yellow-green and blue-green.

Morning Dew, 1993, oil on canvas,
40 × 50 in. Collection of Julie
Isaacson and Matson Haug

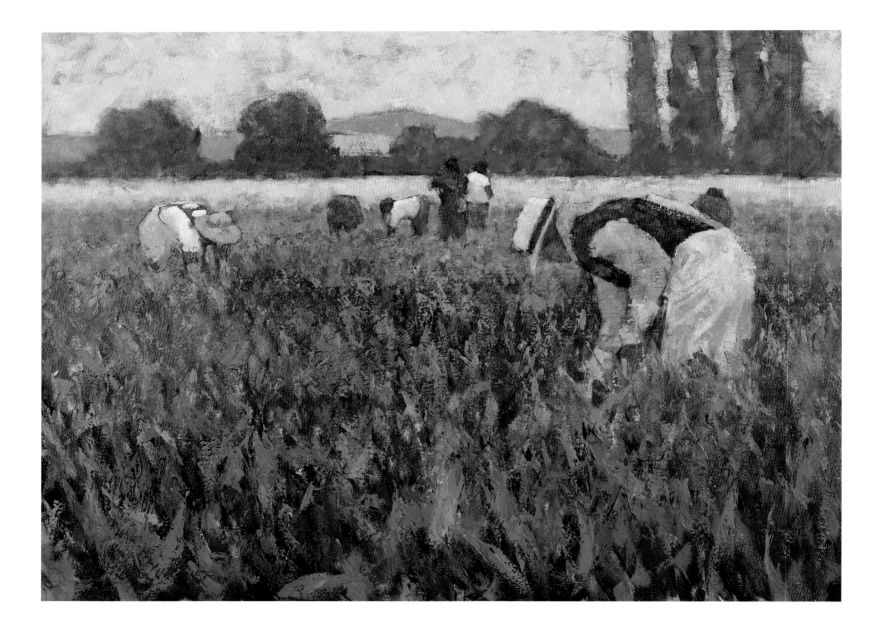

Bed of Iris, 1997, oil on canvas,
44 × 50 in. Collection of Mr. and
Mrs. Brent Hicks

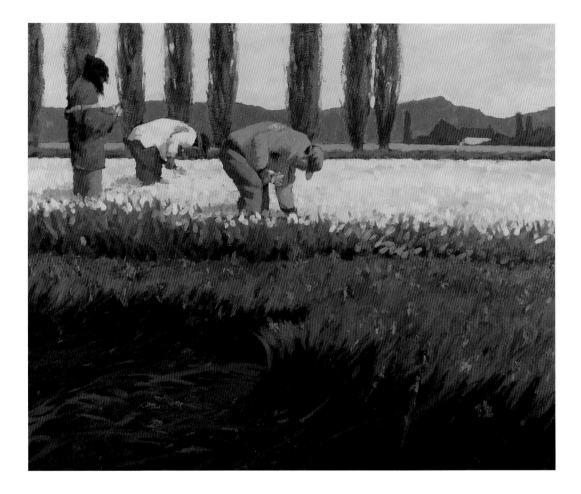

Synergy echoes Renaissance religious painting; the solemnity and silence prevail among the searching, monklike figures. This is a large, ambitious painting. Black hoods, yellow slickers, and waterproof pants—or a hooded jacket in one case—wading in a red "bandscape" of arrow-shaped brushstrokes. What are they looking for? Are they cutting tulips? Digging bulbs? The term "lotus land" helps identify the silence and dreamy contentment the painting first suggests, but these workers are task-oriented and dressed against the cold and damp. Currier never intends a social message in such paintings; he never tells us whether he sees his central characters as happy or disgruntled with their lot, earning a comfortable living or scratching by. All he knows is that he sees these people as literally and figuratively plugged into the earth.

Synergy, 1999, oil on canvas,
36 × 60 in. Private collection
(also detail, pages 92–93)

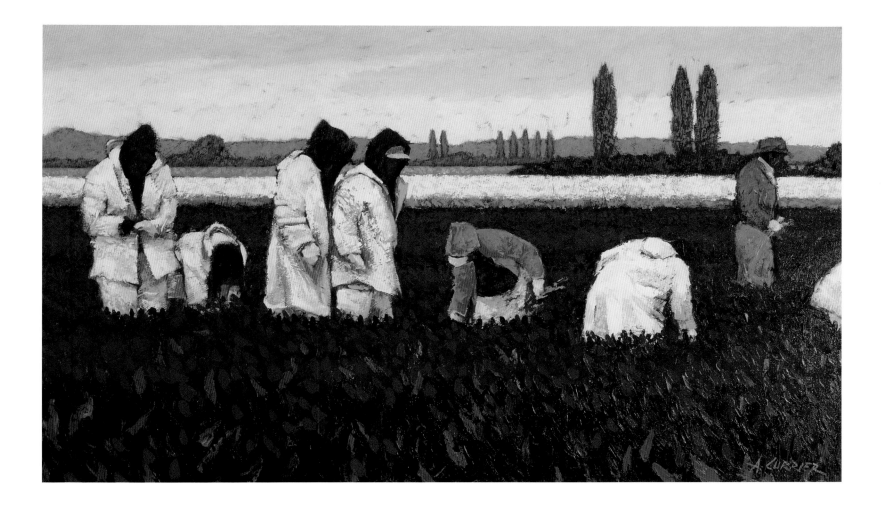

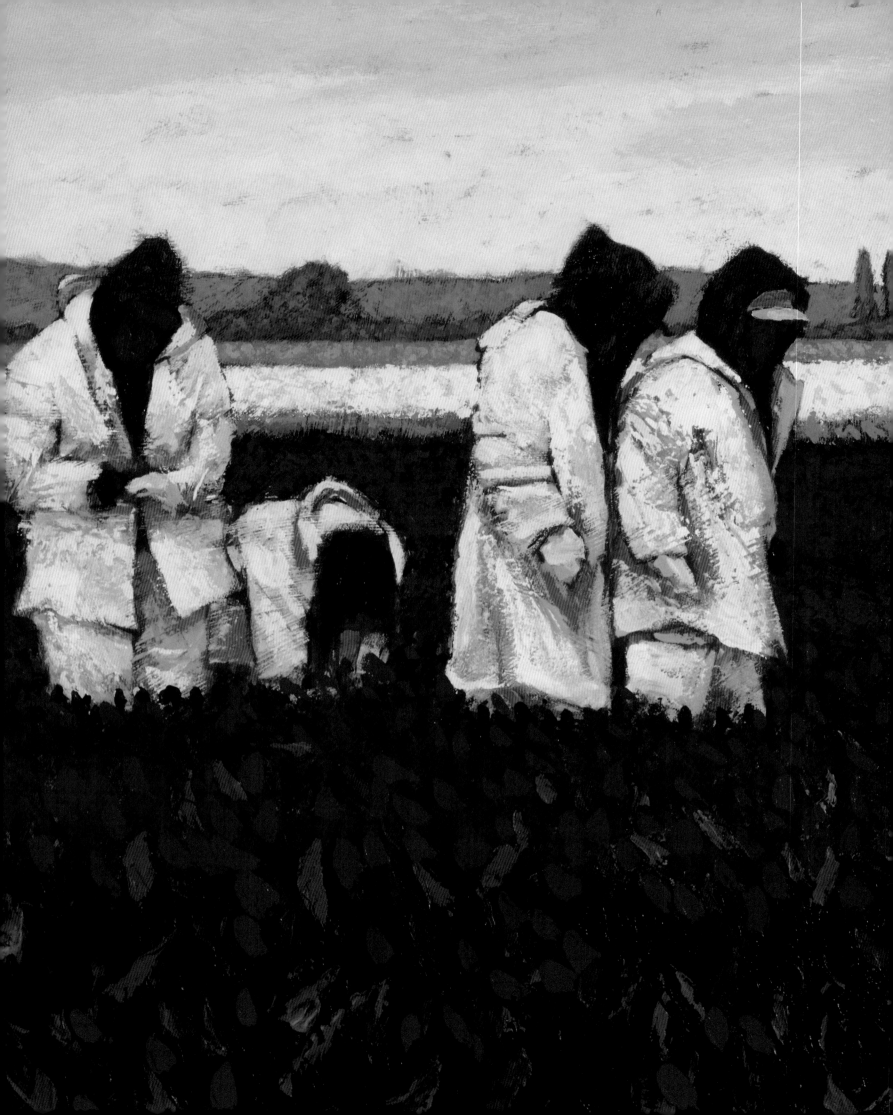

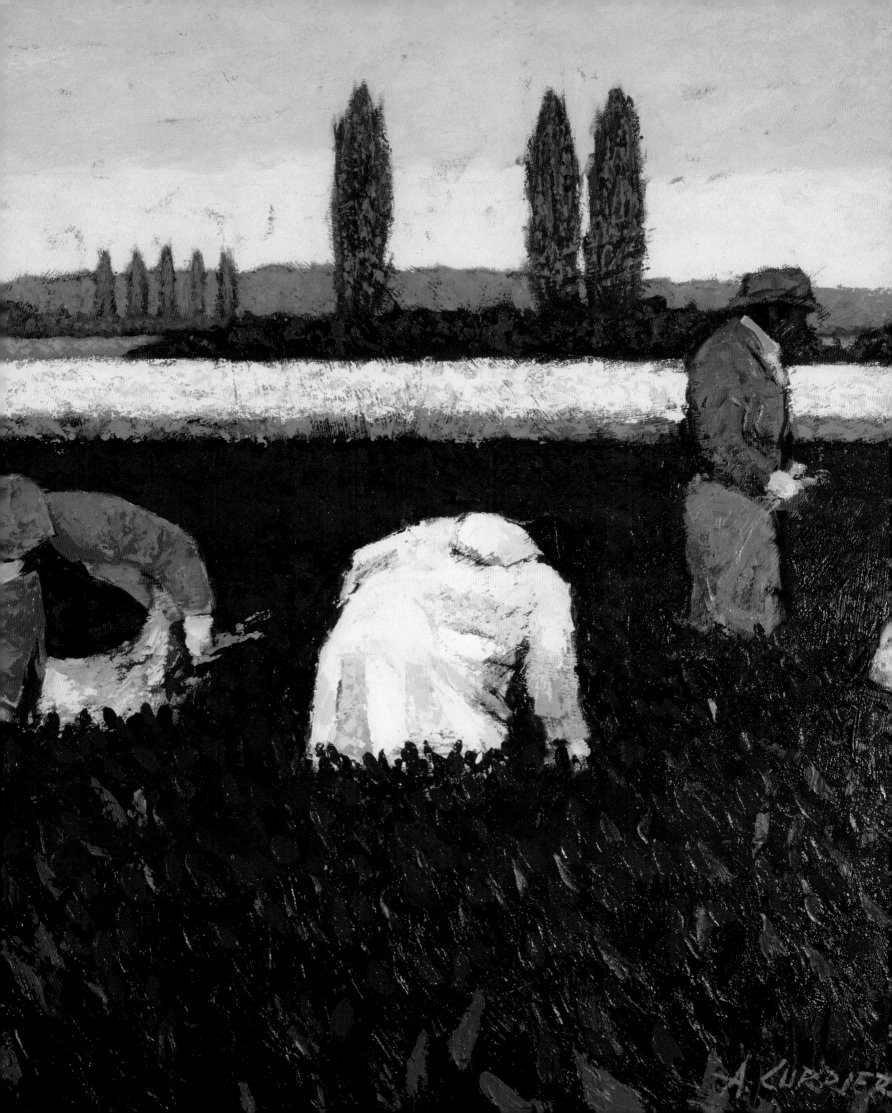

In *Hansa Yellow* Currier celebrates this color value accompanied by a single bent, straw-hatted figure. The blossoms are again stylized arrowheads. There are five or six hues of yellow. The hat is warped. The waistband of the waterproof pants sticks out as if made of stiff and rigid material, a problem in the classic technique of painting drapery. Hat band and suspenders are the same color—Currier "travels" the same brush- or knife-load all the way up into the distant band of trees.

(One of Currier's tulip-field paintings, *Hansa Tulips* [not illustrated], was chosen for the 1998 Skagit Tulip Festival poster, an honor he accepted without quibbling about the true function of fine art. He since has kidded himself about being the "poster child" of that year.)

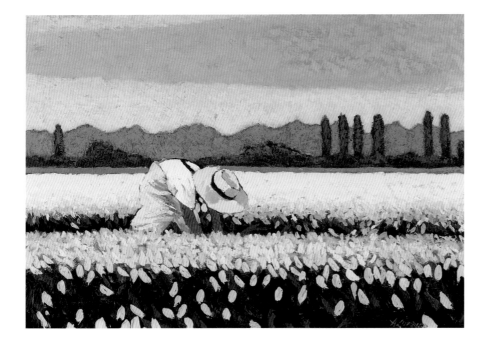

Hansa Yellow, 1997, oil on canvas, 30 × 40 in. Collection of Shirley B. Nielsen

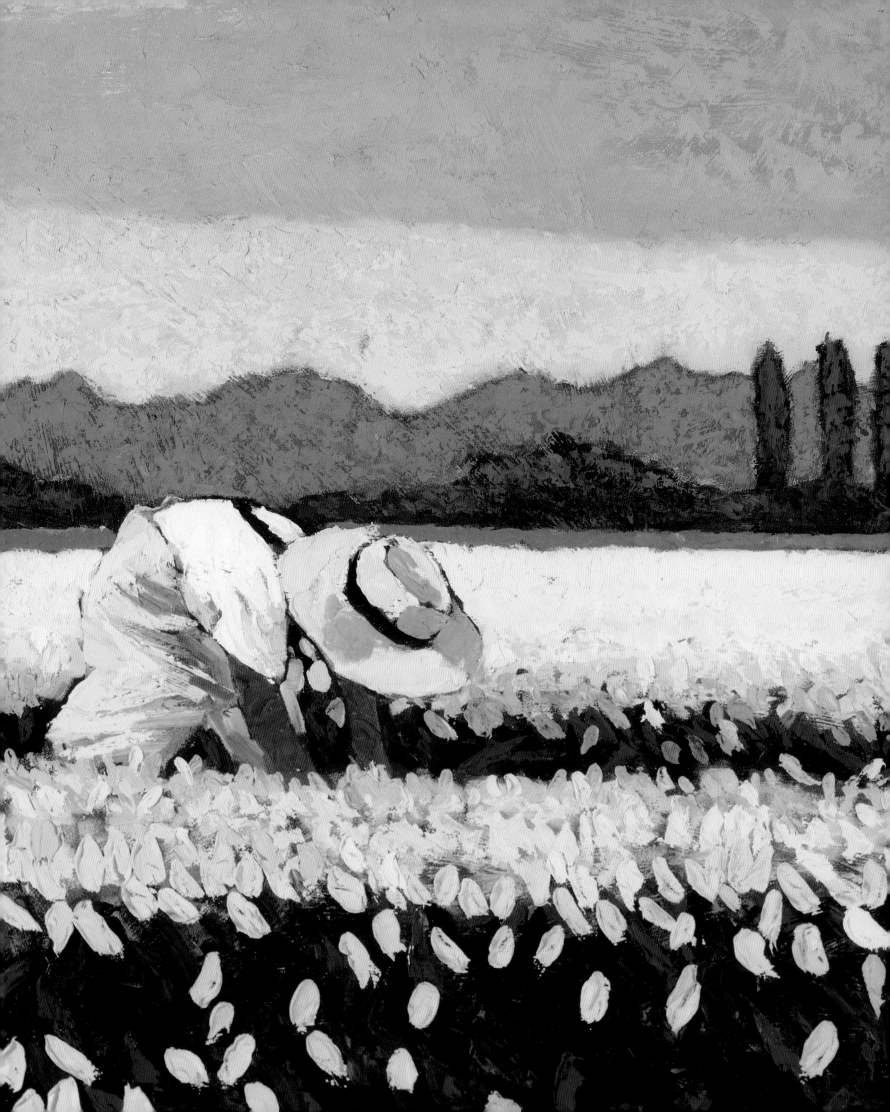

Amarillo, 1999, oil on canvas,
30 × 25 in. Collection of Kathryn
Sievert Hutto and Peter Hutto

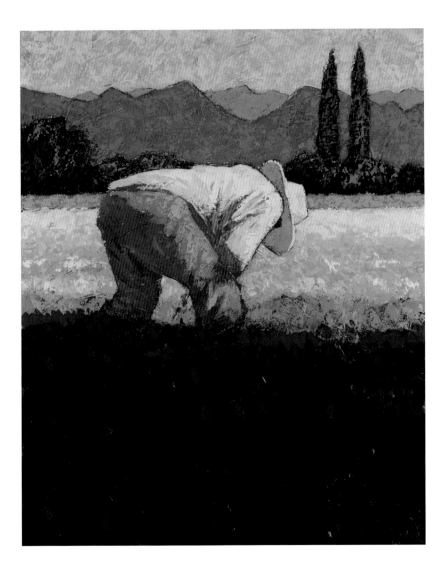

Valley Slough, 1998, oil on canvas,
48 × 60 in. Private collection

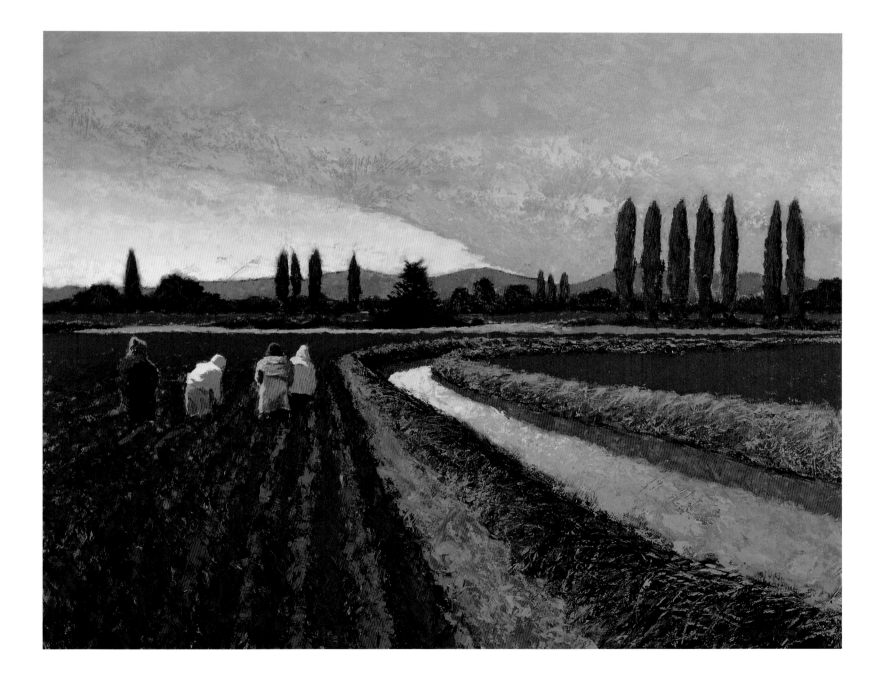

In Contrast, 1999, oil on canvas,
36 × 40 in. Private collection

In Contrast registers rows of yellow, green, deep red, green, yellow, dark green, blue, violet into a definitely yellow sky. Three poplars stand watch. There is a sense that by now the variant details of figures and landscape are so well rehearsed that Currier needn't bother to look at a drawing. The title refers to discrete bands of pale yellow sky, violet-purple mountains, black trees, and yellow buds, bordered by blue-gray shadow below, marking the edge of a stand of red tulips. The picture contains a lone figure in a reflective-white T-shirt, another stand of yellow buds, and a foreground of green grasses. Once the figure has been placed, the "bandscapes" are stacked. He ticks them off, from top to bottom, like a laundry list.

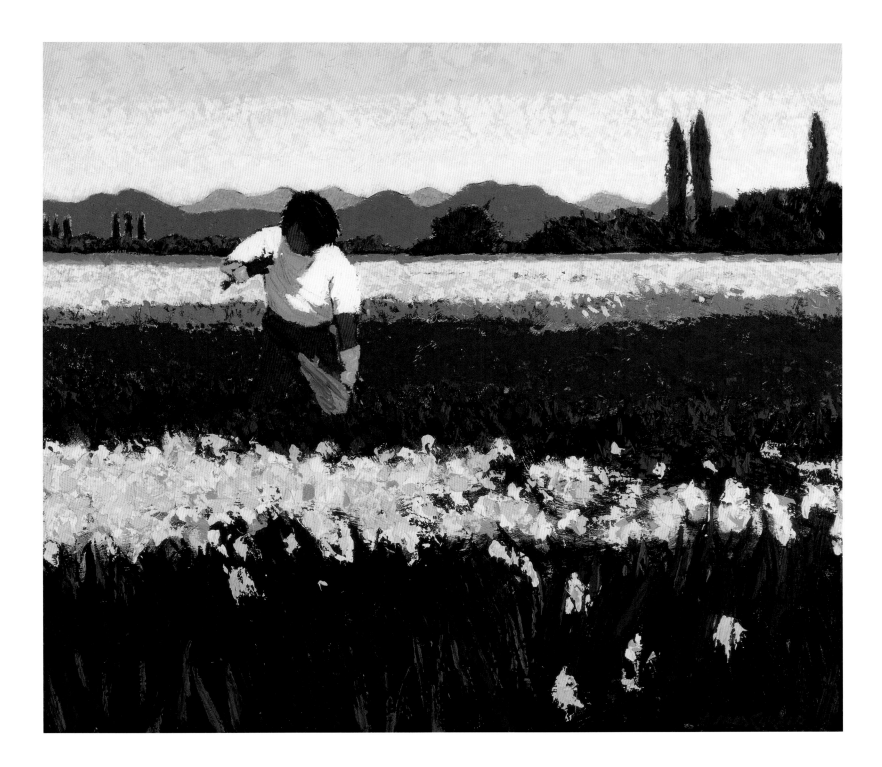

Gathering, 2000, oil on canvas, 48 × 60 in. Collection of Don and Molly Mowat

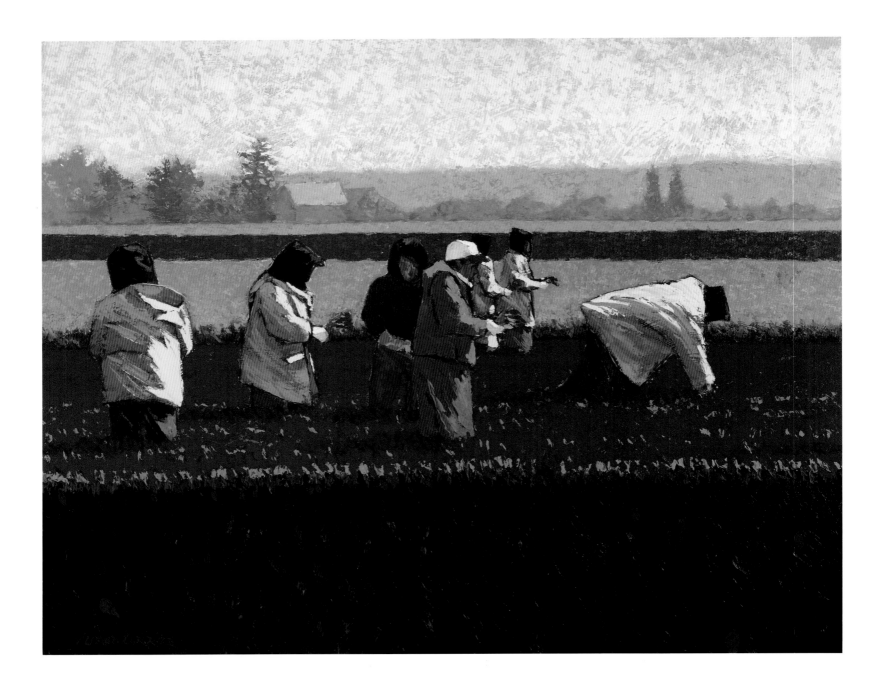

Gathering is similar to *Synergy* (pages 91, 92–93) because of the figures in black hoods. But here there's also an eye-catching white baseball cap at center that is strictly a compositional device. Note the contrast between the sunlit middle ground in brilliant color and the distant gray haze, which makes for visual interest: tension and drama. There are pronounced shadows from the figures in such bright sunlight. These are difficult shadows on a broken surface (the tops of the tulips). The foggy background, characteristic of Skagit County, is genuinely subdued in contrast to Currier's ordinarily high-key palette.

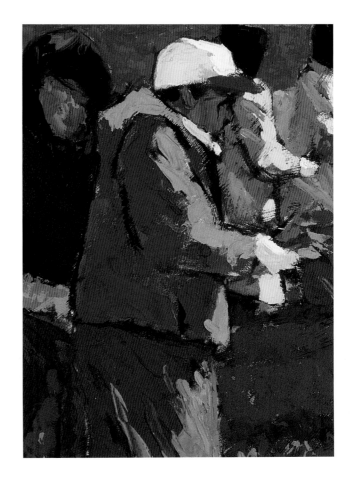

In the painting *Facing East* everything is turned from Currier's usual southward perspective. He is now deliberately facing east, and in doing so, he accepts the in-focus dominance of the blue and violet Cascade Mountains in his formula—more, and more differentiated, mountains. The angle of light suggests early morning. The figures face south with the sun hard on their backs. The central, closest figure is a virtual abstraction, a compilation of Cézanne-like volumes: columns and spheres on a striped plane.

The tulip-field paintings magically multiply through Currier's ability to create seemingly endless variations on a theme. Each time there are differences both subtle and substantive. Nuances of painterly color and surface apart, he nominates new objects to infuse freshness: Here he will capture Fir Island emerging from a plane of silt; there he will bring into sharp focus the Cascades in an almost Chinese mountain-cloud mode; here he will install a massive white truck. In turn, all become new compositional hurdles to vary and heighten the excitement of the painting's construction.

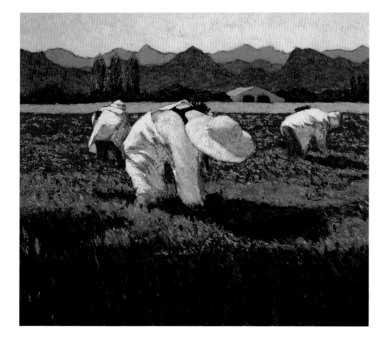

Facing East, 1998, oil on canvas, 40 × 44 in. Collection of Judith and Ken Van Osdol

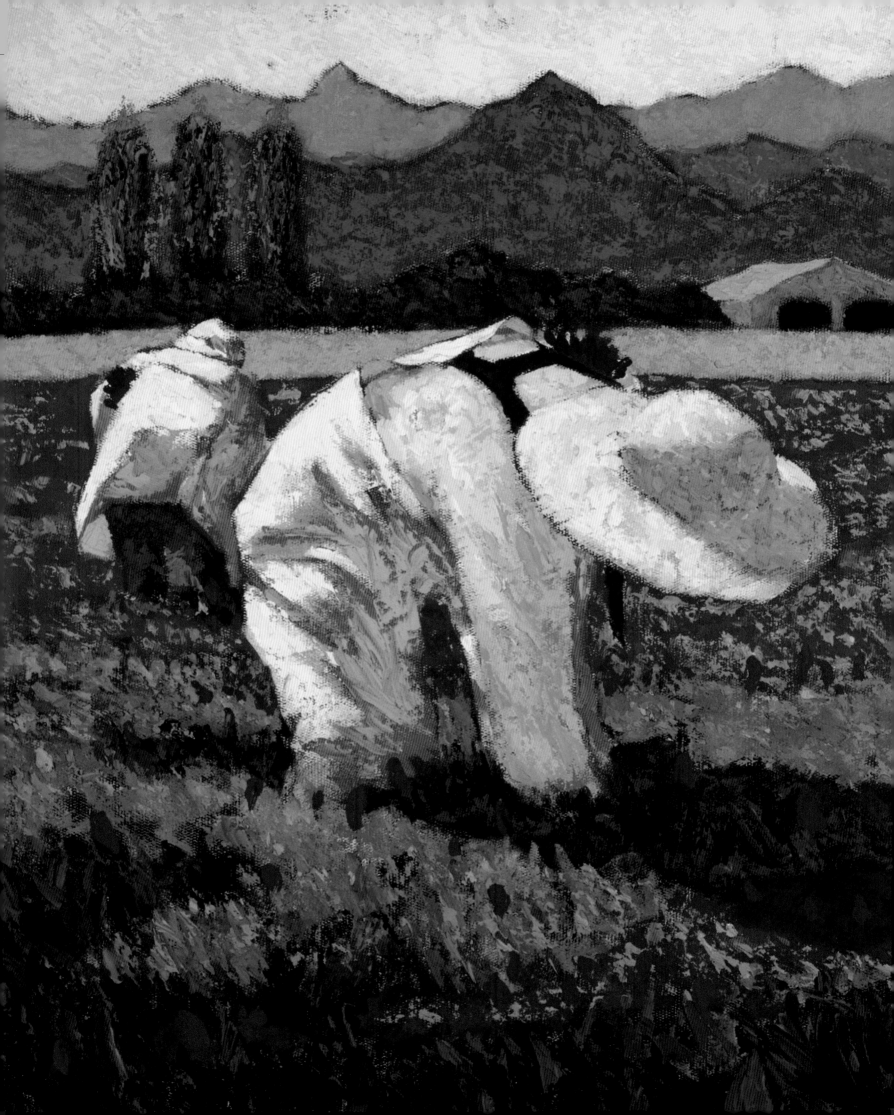

ALL CATS IN THE DARK ARE GRAY

Alfred Currier—this tall, boyish bespectacled fellow, cordial and soft-spoken, with an easy smile above an almost-white beard—reminds us constantly how unaware and unconsidered we are about color in our own surroundings, even as to how our color preferences are conditioned by our temperate rainforest reticence. I think of his humorous "pop-psych" observation that he instinctively knows that the people who gravitate toward his cooler paintings on exhibit are from northern Washington, and the ones who make a beeline for the hotter paintings are probably from California. This is not a value judgment; it is an observation on subconscious color conditioning— including my own, somewhat embarrassing recollection of the choice of illustration I made when I wrote a review of Currier's work some years previously. The painting, more in the German expressionist mode, depicted a woebegone barn in a sodden blue-gray delta landscape.

Currier is not just a visual chronicler of Skagit County—its terrain, its light and weather, its moods. The locale is not as important to him as the working out, the invention of his own inimitable color strategies, and the performance of paint application itself. In the tulip-field paintings, far more stylized than all his other genres, we see Currier's truest artistic resolution in his balance of commercially viable painting with a highly personal art-for-art's-sake, painterly approach that is somewhat mannerist—mannerism here understood as the pursuit of a heightened, often artificial sense of style in which color can become intense or lurid, capable of creating a strong emotional response. He is not interested in becoming a "Northwest painter" of mystic restraint and tertiary colors, grays, and occasional ochers, or a purveyor of what painter Louis Bunce once facetiously suggested was nothing more than "tubed-up fog."

Rather, Currier is a mature technician and craftsman, concerned with the archival longevity of his product, and a solid journeyman-artist who derives his living from what he sells (largely without any kind of backing or academic grants or the blessing of critical or art-historical punditry that sometimes generates a kind of artificial fame). Although working toward an admittedly popular (non-elitist) art market, he yields nothing more than the appearance of representational art. Currier's paintings are never sweet or sentimental, nor, for that matter, are they narrative in any social-realist sense. He remains totally attentive to the primary dictates of fine art, and his achievement in the past decade is to have forged a hard-won covenant between obligatory audience requirement and personal, spiritually fulfilling artistic resolution.

APPENDIX

REPRINT: PREVIEW OF THE VISUAL ARTS

November/December/January 1996/97

ALFRED CURRIER: *Skagit Light and Lowlands*

Scott Milo Gallery, Anacortes, Oct. 5–Dec. 31

The most fundamental question raised by visual art discourse is, of course, "Do you see what I see?" When this discussion is directed toward the continuing, boundless genre of *plein air* landscape painting, stylistic conventions as old as Impressionism and Fauvism are no longer controversial and are read with relative ease. What remains of interest in this singular practice is the invocation of a mystique as private and non-transferable as meditation or fly-fishing: plus the opportunity of once again beating the *camera,* which was supposed to have put an end to all this colour-mixing and paint-daubing in the rough.

When painter Alfred Currier migrated from Chicago to Skagit County, WA, in 1991, his most valuable asset was a fresh recognition of altered light and colour; a new evaluation of the prosaic, yet haunting beauty of an often overcast and rain sodden delta region where the Skagit River meanders several directions into the sea. Currier's adoptive landscape is a tableau long since deforested, dyked and sloughed; punctuated by sentinal stands of windbrake poplars and haunted dairy barns, no longer needed for the proliferating tulip, turf and potato farms. What Currier sees, aside from the annual excesses of 'colour-field painting' provided by the tulips, themselves, is a light-filtered, temperate and benign place so remarkable to newcomers—so easily blamed for melancholia by residents who impatiently pass through that same landscape merely to get 'somewhere.'

© Ted Lindberg

SELECTED BIOGRAPHY

Born in 1943 in Allentown, New Jersey
Resides in Anacortes, Washington

Education

American Academy of Art, Chicago, Fine Arts graduate
Columbus College of Art and Design, Ohio, two years
Art Students League, New York
Ohio University, Chillicothe
Franklin University, Columbus, Ohio

Teaching

Palette and Chisel Academy of Fine Arts, Chicago
Overland Park Community College, Kansas
Arts Center of Kansas City School of Fine Art, Missouri
Art Adventures, Taos, New Mexico
Coupeville Arts Center, Washington
LaConner Art Workshops, Washington

Collections

Miller/Nash Law Firm
4-H Foundation
Lehman Brothers
Skagit Valley Tulip Festival

Noted Exhibitions and Honors

2000 Laguna Art Museum, Laguna Beach, California, Laguna Plein Air Painters Association July Invitational

1998 Seattle-Tacoma Airport, *Skagit Valley Legacy*

1998 Pinnacle Gold Award, International Society of Festivals for the 1998 Skagit Valley Tulip Festival Poster

1994 Waterfront Festival Poster Artist, Anacortes, Washington

1993 Frye Art Museum, Seattle group exhibition

1992 New York, Knickerbocker 42nd National Exhibition

1991 Wichita, Kansas, Small Oil Painting National Exhibition

1987 Beverly Art Center, Chicago, Annual Baer Art Competition

1987 Union League Club of Chicago, Civic & Arts Foundation Grant Recipient

1983 Beaux Arts Recipient, American Cancer Society

Selected Exhibitions

2002

Lawrence Gallery, Sheridan and Portland, Oregon, anniversary group exhibition

Insights Gallery, Anacortes, Washington, group exhibition

2001

Lawrence Gallery, Sheridan and Portland, Oregon, solo exhibition

Patricia Rovzar Gallery, Kirkland, Washington, solo exhibition

2000

Lawrence Gallery, Sheridan, Oregon, solo exhibition

Scott Milo Gallery, Anacortes, Washington, solo exhibition

Patricia Rovzar Gallery, Kirkland, Washington, group exhibition

1999

Lawrence Gallery, Sheridan, Oregon, solo exhibition

Waterworks Gallery, Friday Harbor, Washington, solo exhibition

1998

Scott Milo Gallery, Anacortes, Washington, solo exhibition

Patricia Rovzar Gallery, Kirkland, Washington, group exhibition

1997

Lawrence Gallery, Sheridan, Oregon, solo exhibition

Scott Milo Gallery, Anacortes, Washington, solo exhibition

Waterworks Gallery, Friday Harbor, Washington, solo exhibition

1996

Scott Milo Gallery, Anacortes, Washington, solo exhibition

The Source Fine Art, Kansas City, Missouri, solo exhibition

1995
Kimzey Miller Gallery, Seattle, solo exhibition
The Source Fine Art, Kansas City, Missouri, group exhibition

1994
Runnings Gallery, Seattle, solo exhibition
Cabiri Fine Art, Anacortes, Washington, solo exhibition
Lawrence Gallery, Sheridan, Oregon, group exhibition
Taos Gallery, New Mexico, group exhibition
Louisiana State University, Baton Rouge, group exhibition

1993
Paperstone Gallery, Anacortes, Washington, solo exhibition
Anacortes Arts Foundation, Washington, solo exhibition
Cabiri Fine Art, Anacortes, Washington, group exhibition
Runnings Gallery, Seattle, group exhibition
Taos Gallery, New Mexico, group exhibition

1992
Runnings Gallery, Seattle, group exhibition
Taos Gallery, New Mexico, group exhibition
Paperstone Gallery, Anacortes, Washington, group exhibition
Palette and Chisel Academy of Fine Arts, Chicago

1991
American Legacy Gallery, Kansas City, Missouri, solo exhibition
Taos Gallery, New Mexico, group exhibition
Stonington Gallery, Seattle, group exhibition

1990
American Legacy Gallery, Kansas City, Missouri, solo exhibition
Wichita Gallery of Fine Arts, Kansas, group exhibition

1989
O'Hare International Airport, Chicago, solo exhibition
American Legacy Gallery, Kansas City, Missouri, group exhibition
Newman Gallery, Scottsdale, Arizona, group exhibition

1988
Studio in the Woods, Wauconda, Illinois, solo exhibition
Third Coast on Dearborn, Chicago, solo exhibition
Chicago Board of Trade, group exhibition

1987
Palette and Chisel Academy of Fine Arts, Chicago, solo exhibition
Arlington Arts Horse Racing Exhibition, Illinois, solo exhibition

SELECTED BIBLIOGRAPHY

Alfred Currier. "An Artist's Perspective," *Art Calendar,* July/August 2002.

"Lawrence Gallery Presents Alfred Currier" (review), *Arts News Mid-Valley Arts Council,* Salem, Oregon, November 2001.

Brooks Jensen. "A Painter Looks at Photography," *Lenswork,* January 2001.

Nancy Walbeck. "Painter Currier Re-visits California Plein Air," *Anacortes (Washington) American,* May 2000.

Review, *Art Business News,* December 2000.

"Artist Currier Shows His Art, Raises Funds in San Francisco," *Anacortes (Washington) American,* October 25, 2000.

Sharon Nagy. "Plein Air Painting Competition Draws Artists from Across the Nation to Depict Outdoor Scenes in Laguna Beach," *Los Angeles Times,* July 19, 2000.

Nancy Friedman. *Art of the State of Washington,* New York: Harry N. Abrams, 1999.

Nancy Walbeck. "More Than a Plein Air Life," *Anacortes (Washington) American,* January 7, 1998.

"Spring Blooms in November," *Skagit Valley (Washington) Herald,* November 19, 1997.

Mary Leone. "Painting Impasto Landscapes," *American Artist,* August 1997 (with cover illustration).

D. Tennant. "Best of the West," *Southwest Art,* April 1997.

Review, *Arts News Mid-Valley Arts Council,* Salem, Oregon, April 1997.

Lavone Newell. *Skagit Valley Fare: A Cookbook Celebrating Beauty and Bounty in the Pacific Northwest.* Anacortes, Washington: Island Publishers, 1996 (cover illustration).

Ted Lindberg. "Skagit Lights and Lowlands," *Preview of the Visual Arts,* November 1996.

Mary Leone. "Prestigious Seattle Galleries Feature the Works of Anacortes Painters Alfred Currier and Anne Martin McCool," *Skagit (Washington) Argus,* July 12, 1995.

"An Original Work of Art" (review), *Cass County Democrat-Missourian,* June 24, 1994.

Chara M. Curtis. *How Far to Heaven.* Paintings by Alfred Currier. Bellevue, Washington: Illumination Arts, 1993.

Nancy Walbeck. "'Heaven' could be Right Here in Anacortes," *Anacortes (Washington) American,* November 17, 1993.

Mary Leone. "Truly Heaven Is Found," *Fidalgo Magazine,* October 1993.

Nancy Walbeck. "Al Currier: Fidalgo Impressions," *Anacortes (Washington) American,* May 29, 1991.

ACKNOWLEDGMENTS

From inception to completion, this book wouldn't have been possible without the diligence and undaunted efforts of Anne Schreivogl.

Every once in a while someone comes into your life with the ability to peer into your soul. Ted Lindberg's weeks of interviews and observations are consummated with this in-depth chronicle of my world.

Professionalism comes in the form of people who not only know what to do but how to do it with the highest degree of expertise and style. These contributors are: Ed Marquand, Mitch Everton, David Neri, Chara Curtis, Norah Kembar, Michael Falter, Jeff Wincapaw, and Marie Weiler.

I give special thanks to the patrons who so generously gave to this project.

Influences in my life come mainly from family—present, future, and past. With my sister Jenny, my son Pat with his wife Angie, and my daughter Chris with her husband Pat, stability and love are in the present. My family of wide-eyed grandchildren—Kelly, Sarah, Haley, Tommy, and Aaron—give excitement and hope to the future. Fond memories of women in my past are held for Regina, Phoebe, and my mother Dorothy.

—Alfred Currier